Life,
Paint
and Passion

Life, Paint and Passion

Reclaiming the Magic of Spontaneous Expression

MICHELE CASSOU AND STEWART CUBLEY

A JEREMY P. TARCHER / PUTNAM BOOK
published by
G. P. PUTNAM'S SONS
NEW YORK

A JEREMY P. TARCHER/PUTNAM BOOK
Published by G. P. Putnam's Sons
Publishers Since 1838
200 Madison Avenue
New York, NY 10016

Most Tarcher/Putnam books are available at special-quantity
discounts for bulk purchases for sales promotions, premiums,
fund-raising, and educational needs. Special books, or book
excerpts, can also be created to fit specific needs.

For details, write or telephone Special Markets, Putnam
Publishing Group, 200 Madison Avenue, New York, NY 10016.
(212) 951-8891.

Library of Congress Cataloging-in-Publication Data

Cassou, Michele.
Life, paint and passion : reclaiming the magic of spontaneous
expression / Michele Cassou and
Stewart Cubley.
p. cm.
ISBN 0-87477-810-7
1. Painting. I. Cubley, Stewart. II. Title.
ND1500.C36 1996 95-30195 CIP
751.4—dc20

BOOK DESIGN BY DEBORAH KERNER
COVER DESIGN BY SUSAN SHANKIN
COVER ART BY MICHELE CASSOU

Printed in the United States of America
7 9 10 8

This book is printed on acid-free paper. ∞

acknowledgments

This book would not have been possible were it not for all the wonderful students who have participated in our painting classes and workshops over the years, who have shared their hearts and minds with us while exploring in depth the creative process.

We wish to give heartfelt thanks to Jeremy Tarcher for publishing and editing this book, and for his unwavering appreciation and support during the various stages of its creation. Special thanks to our editor, Robin Cantor-Cooke, for her numerous, perceptive suggestions as well as her will-

ingness to be available beyond the call of duty at all hours of the day and night.

Grateful thanks to Mary McKenney for her intense personal and editorial involvement in the book since the early days of The Painting Experience Studio. Also thanks to Geneen Roth for her stimulating and loving encouragement, to Robert Chartoff for introducing us to Jeremy Tarcher, and to Susan Lockary, Joanne Broatch, Penni Wisner, and Marty Newman for their helpful comments and suggestions. Also thanks to Fella Cederbawn for her insistent vision of the book over the years and Samantha Nieman for her unending enthusiasm in transcribing many audio tapes. Thanks to Natalie Goldberg, friend and fellow painter, for her warm support of our work and her willingness to write the foreword. Also thanks to the students who have kindly let us use their photographs, paintings, and comments; to Barbara Kaufman and Jan Haller for their loving help in running the studio during such a demanding time; and to the children's studio in Paris that got us started on this journey.

And most of all, thanks to the creative process itself, for its gift of spirit and freedom without which our lives would have been so different.

contents

*M*ichele Cassou is the originator of the work, through both her in-depth experience in the painting process and her founding of the method over two decades ago. Stewart Cubley joined Michele in 1976, and together they have taught this method to thousands of people who have passed through the doors of The Painting Experience^sm in San Francisco—a studio where people find a warm, supportive atmosphere in which to explore their deepest fears and highest joys on the creative path. Their work has proved to be of interest within a wide range of disciplines, including art,

psychology, education, therapy, and meditative practices. Today The Painting Experience continues to grow and to touch many people's lives, providing a tool for meeting and going beyond the boundaries of the known. The first-person voice in the book belongs sometimes to Michele, sometimes to Stewart. When it is important to distinguish between the voices, the speaker's initials are used.

foreword

*I*n 1991, *Yoga Journal* did an article on creativity. The author, Anne Cushman, took workshops in different creative disciplines and then interviewed their leaders. She wrote about my workshop and also about The Painting Experience, led by Michele Cassou and Stewart Cubley. I remember Michele's photo on the *Journal*'s cover: arms crossed, four paintbrushes in her right hand, long bangs on her forehead, a confident grin, sparkling eyes—she was inviting me to paint. And I wanted to oblige. I promised myself I

would someday study with her. Then I opened the magazine and read the article.

Michele and Stewart were blazing a trail in painting similar to the one I was forging in writing. It delighted me. I imagined the kind of instructions they called out in class: "Pick up a brush, dip it in the first color that flashes through your mind, run it across paper. For heaven's sake, don't worry about good or bad. Just do it!" But San Francisco seemed far from Taos, New Mexico, where I lived. I never managed to get over to their workshop.

Three years later, I was visiting an old friend who owned an art gallery in Berkeley. I was peering at the paintings on her gallery wall when she asked, "Do you want to see mine?"

"Yours?" I said, openmouthed. I never knew she painted.

She laughed, slid open a drawer, and brought out a huge pile of paintings. I was stunned by the intensity of feeling, the vivacity, the raw truth on those sheets of paper.

"These are you!" I said, amazed. I was looking at her great spirit, the one that had never quite manifested in daily life, my friend's innermost being expressed in the immediate, urgent medium of color. It was as if she had stepped through all her judgments and inhibitions and unveiled her true self. And what was astonishing for me was how visceral paint could be. I could write about myself on a piece of paper, sitting at a table among many people, and no one could see what I was writing. But painting was about open-eyed contact. The moment a brushstroke was on paper, it was exposed

to everyone's view. Painting spoke instantly without words, and my friend's paintings communicated not with ordinary images in typical perspective—a tree next to a house with a couple waving from a front porch—but with images slashing through our usual reality: a baby screaming from the top of a moon, green flames streaming from an upside-down house.

"You like my pictures?" My friend was overjoyed. "I did them in a workshop called The Painting Experience." I remembered from the magazine that Michele and Stewart cautioned their students about showing their work—they emphasized process, not product—yet my passion was aroused.

"What is their phone number?" I asked. There was no hesitation this time. I walked across the room and picked up the receiver.

I have learned much about painting from Stewart and Michele. But learning is not limited to the physical act of applying paint to paper. Through The Painting Experience, I have located crannies of resistance in my mind and opened them up. I've been freed from concepts of inadequacy, from limiting opinions of what's beautiful, from censoring emotions and desires. At one point I bolted from the workshop to finish writing a chapter that had been giving me much difficulty and was suddenly revealed as my brush stroked the paper.

In working with Stewart and Michele, I found I had to give up my idea of what a painting should be: portraying a beautiful scene in a pleasing way. Instead, it is about the alive act of moment-by-moment listening to the flashes of

thought at the periphery of perception, and responding in color and form. They taught me what I knew to be true in writing but now had to learn in another medium: that creativity is a process, that it takes practice and intuition, that it is full of surprise and discovery and cannot be known ahead of time.

This book is an extended deep meditation on what it means to be alive and to express one's true being. It is about mining the uncensored self, that part of us that is our life's blood, the true foundation of creativity. I am moved by the writing, which is full of urgency and dedication; Michele and Stewart want to share what they know. And they know a lot! This book is thorough, detailed, and leaves no aspect of the force of inspiration and vision untouched. I almost envy them their medium—painting seems so delicious, lush, exuberant. Color seems the gateway to the place where words falter.

Anyone with the desire to create should read this book, for what is written here reaches far into the psyche and the realm of human suffering and delight. It cannot be digested at one sitting, but that is the great luxury of books. This one can and should be read again and again: the first time, perhaps, with surprise; the fourth time maybe for serious study. *Life, Paint and Passion* provides what every creative spirit thirsts for: a long, slow drink of the experience of the imagination.

NATALIE GOLDBERG

this book

In creative painting, the defining moment is when you face the fertile white void. Your openness and your courage to step into that void with the spirit of exploration are all that matter. The power of painting lies in the creative process itself, not in the resulting product.

Almost all traditional art endeavors are concerned with producing "art." The product of the creative action is put forth, subtly or not so subtly, as the final fruit of the creative experience. Creativity is equated with its results, and therefore must be justified by explanation, analysis, critical evaluation, and superimposed meaning.

It is the basic tenet of this book that the creative pro-
cess is enough. It is not only enough, it is a doorway into a
direct experience of the essential life force which is at the
root of the urge to create art. It is the process itself—in the
creative energy it releases, in the new perceptions it brings,
and in the deepened connection with oneself it fosters—that
is at the heart of the desire to paint. To make this the whole
point of painting is a simple yet radical act.

This book is the outcome of nearly thirty years of inten-
sive work with painting as process. It has grown out of our
own personal journeys into the creative process, and out of
our interactions with many students as they overcame cre-
ative blocks and discovered in themselves the wonderful
freedom to be found in painting. In the classes and work-
shops at our studio, we have created a space where there is
absolutely no compromise with the creative process. No im-
portance whatsoever is placed upon the finished product: we
do not critique the paintings or interpret their meaning, and
we do not encourage their commercial use in any way. The
inner experience of creating is the touchstone for everything
that happens. Once this groundwork is established, some-
thing deep within relaxes and the real life-transforming work
can begin.

Life, Paint and Passion is a book about unlearning. It is
not meant to be used as a textbook, or even as a course in
creativity, but as a catalyst. It is essentially meant to open
the space for you to paint—to arouse your curiosity and your
desire to create, and to show you how readily available your

creativity is. The tools to paint naturally are already within you; they need only a simplification, a clearing of the ground, to manifest. The suggestions presented here are designed to challenge your self-imposed barriers to creativity; they are a departure point into your own experience rather than rules to follow.

It is our hope that as the chapters unfold, you will discover a growing excitement about painting, an instinctual urge to play with color and form as you did when you were a child. Play is one of the most basic and primitive elements of the human psyche, and ultimately art is simply a deep and essential play. Tools for playing with brushes, paint, and paper are presented in a simplified and accessible way in the appendix at the end of the book.

Our experience, after working with many different types of people, is that a hidden wave of passion lies just below the surface of most people's lives, a passion yearning to be liberated from the paralyzing myths of talent, skill, inspiration, accomplishment, success and failure, and just plain not being good enough. This book is about daring to let that passion speak. It is time to throw off the shackles, to reclaim that which every child knows and is taught to forget: the essential right to create without interference or shame.

MICHELE CASSOU
STEWART CUBLEY

the beginning

M. C.

It all started when I met the children. In 1965 I was wandering in Paris, looking for a purpose in life. I was studying traditional subjects at the university while growing dissatisfied and coming close to despair. A year earlier I had given up painting on the advice of my last art teacher: "Do something else, painting is not for you!" For him it was a sophisticated discipline; first you had to study it, learn the technique in depth, then paint some visual perceptions. He thought my demands were illegitimate, my needs over-

whelming; he could not conceive of art as the pulse of the universe. "If you want to express yourself, write, don't paint," he told me. It was true that I had no talent, no patience to study technique. I had tried a few art schools; in all of them I found rules, criticism, competition, dryness, and boredom. In my teachers' eyes I never saw a spark of passion, of astonishment, or gratefulness for the creative process. It was all concept; what could they teach me? Discouraged, I gave up. Maybe I was not meant to be an artist. I explored new directions, new studies; but I was left with a sense of emptiness.

Then I met the children. A series of coincidences put me in touch with the Free Expression Studio in Paris, where I was to be an observer as part of a teacher-training program. As I stepped through the small multicolored door into the studio, my eyes opened to a new level of creation. The room was vibrating with a strange, mysterious energy; colors were floating in the air with a deep sense of power. The little bodies of a dozen children were pouring out forms and images, guided by inner desire, riding with it. An overwhelming sense of happiness burst inside me. For the first time in my life I had finally found a place where I belonged.

Every cell, every inch, every look had the powerful quality of the real. Sheltered from judgment, criticism, and competition, the children were giving themselves to the natural process of expression, to the pulse of creation. Every feeling had its place; the deep tension of the psyche, the mysterious cravings, the dark feelings, the ancient aches—

all were carried by the river of life, reconciled, exposed, whole. There was nothing to hide, nothing to pretend; there was no shame or pride.

The children were between five and twelve years old; I was going to be twenty-two. Would I dare to paint with them? I approached the man who had created the studio and timidly asked, "Could I come just once and try a little?"

The emotion was strong when I first held a brush and touched the paint. What a delightful feeling to paint with the children in safety! The vortex of their creation embraced me, absorbed me. I entered with delight into pure process, giving up product, progress, and goal. I could paint as ugly, as gross, as childish, as violent as I wanted to. There was no more need to think about my work, no border, no limit, no need for definition. I did not have to explain anything to anyone, not even to myself. I had found another language.

Every hour spent with the children was a blessing. From morning to night I would paint, utterly moved by life entering me, awakening me. "Anytime Michele paints, she cries, she can't paint without crying," said a voice in the hall. They were not tears of sadness, but of astonishment. The creative energy possessed me beyond any expectation, any dream; it even scared me a little, for I could not comprehend it. The painting was creating itself, with speed, certainty, meaning. I would watch, amazed, as the images appeared without choice. From a traditional point of view,

my paintings looked childish, bold, disproportional. It did
not matter. I was so grateful to the universe that I could only
send thanks to whatever came out of me and love it. I had
found passion. Nothing could stop me.

Where would life lead me if I let the river run? I wanted
to find out. The whole structure of who I thought I was had
started to crumble. In a few days I had unlearned years of
knowledge, because I saw how hollow and absurd it was to
search for life outside myself. Soon my way of living
changed. I discovered in myself a hunger for less sophistica-
tion and a thirst for more direct contact with life.

"Painting is like a drug for you!" said a friend of mine. I
was drunk with it, it was true—drunk with freedom, pos-
sibilities, space, wonder. I had never been encouraged to
respond to the magic of freedom, to dive in and really ex-
plore. Buried in fear, I had been holding tight to security,
tradition, comfort, dreading the dizziness of creation. But
now I saw that there was nothing to lose. After all, what else
is there to do on this earth than rediscover the natural direc-
tion, the natural language of total expression—the source of
it all?

about the paintings . . .

*I*t has been a delicate decision to show paintings when the central message of this book is about process. Yet we thought that seeing paintings by participants in The Painting Experience could stimulate and encourage you to discover for yourself the magic of spontaneous expression.

Paintings must be viewed on the same ground from which they were created—their aliveness, their energy, their vulnerability—in order to be appreciated. The visible painting is just the echo of a much greater process. What is reflected in the forms, images, and colors is the by-product of a journey that has taken place on an inner landscape. The real painting has been created on the canvas of the psyche; the true artistic product is the personal transformation that has taken place within the painting experience itself.

my journey

S. C.

My creative journey began in Alaska in 1970. I was a graduate student in geophysics and a few months from my Ph.D. when I dropped out to live in a small cabin I had built in the wilderness outside Fairbanks. I was going against all good sense by walking away from so many years of education, but it seemed I had no choice. I felt a growing need to find a way of living more in harmony with intuition and feeling rather than with rationality and expediency. Something inside was pushing me to abandon all that I had known before.

I spent the next three years in quiet isolation, living with the rhythms of nature in my cabin, the cold dark days of winter followed by the bursting forth of light and growth in summer. I was grateful to live in a simple way where I could sense myself more deeply. I delighted in my newfound solitude and savored the time far away from human contact and commerce.

In the spring of the third year I felt a growing restlessness. I began to feel an attraction for what lay beyond the perimeter of my little forest; I was ready to come out of the cocoon I had created. I said a ritual good-bye to my precious cabin, leaving for what I thought would be a short visit to the outside.

I met Michele in Switzerland, where we were both traveling abroad for the summer. I remember first seeing her paintings, then watching her paint. I was intrigued by a process that was so foreign to me, yet intimate and familiar at the same time. I was moved by the commitment to the intuitive realm that she had discovered through painting. Her experience resonated strongly with my own convictions, and having painted but once in my life, I took up the brush.

Painting seemed very awkward at first, and I suspected that it was not my medium. As I watched Michele, I could see that there was depth and authenticity in her painting process, but was not sure that I could work with it myself, for I was inexperienced and up to this point had never been interested in art. But after a few short months these doubts were dispelled. Exciting new vistas opened before me, and I

began to have moments of release and insight. I felt re-energized each time I painted, mystified that such a simple act could be so powerful. Painting became a form of meditation that took me as deep within myself as had the long silent days of the Alaskan winter.

As I began to work with children and then later with adults, guiding them through the painting process, I found great satisfaction in intuitively sensing others' needs and helping them overcome creative blocks. I became fascinated by the intimacy and intensity of these interactions as I watched people rediscover the well of their own creativity. What a strange destiny to have found myself involved in something so different than anything I could have imagined! The painting process had become for me a metaphor to explore the deepest sources of human nature, as well as my life's work.

Out beyond ideas of wrong doing and right doing
there is a field.
I'll meet you there.

Rumi

Life,
Paint
and Passion

the unteacher

M. C.

Fate played a trick on me when it made me a teacher. I started this new career quite unknowingly, when I first lured my friends to come to dinner at my house once a week. My only purpose was to have them paint right after dessert. I delighted in watching them create, although I did not understand why their enthusiasm was so limited.

"You can be free from every rule and expectation!" I would exclaim, with fire in my voice. "Painting has changed my life. Don't you see the tremendous opportunity?"

No, they did not, even though I could see the potential in them, with its beautiful magic and pregnant possibilities.

They moved their brushes with such little eagerness. Their beings would not respond to the gift; their creative organs were asleep, forgotten deep inside, unused. And yet I could feel the seeds of happiness in their bodies as if in my own.

I was so intrigued by such a paradoxical reality that without giving it a second thought I became a teacher. I started having groups in my home, where I happily transformed my bedroom into a studio. I had to find out why people would not let themselves create, why they did not want to feel, why they refused a great gift I knew they were longing for. I shivered at the thought that I might have missed it myself.

As I learned more and more about the workings of creativity through watching myself and my students, I realized that my main function as a teacher was to destroy the bindings attached to the idea of creation. It was to have people recover their natural instinct to play, to invent, to listen to their intuition. I discovered that my role was to give them nothing—nothing that they could tangibly use—so that they would have to dig in themselves for everything: colors, shapes, proportion, images. I would often announce, "I am not going to give you anything you can put in your pocket. I hope you will know less when you leave here—not more!" My function was to destroy their beliefs about what they could not do. I wanted to make them see that all they needed and wanted was already inside them, like the water in a well that never runs dry. Most of all, I wanted them to realize how thirsty they were. I had become the unteacher.

My students were students of themselves; the real teacher was the painting process. Together we have had a wonderful and intense time unlearning, playing, and discovering, while giving life a chance to manifest.

The unteacher and the unstudents . . .

process vs. product

You paint for process or you paint for product. This book is about painting for process. It sounds very simple, but it is a radical thing, because usually we want something out of what we do. We want a painting we can use, we can sell, we can show, something that can prove our worth.

If you paint for product you have a certain result in mind. You have a direction, a goal, a place you are trying to reach—you follow a map. If you paint for process you can go anywhere. There is freedom. Possibilities are endless.

If you paint for product you have to follow the rules that keep you on the track of your expectation. You have to calculate, organize, plan every move. When you paint for process you listen to the magic of the inner voices, you follow the basic human urge to experiment with the new, the unknown, the mysterious, the hidden. Process is adventure; product happens only within the parameters designed.

You don't need a special gift in order to paint for process. You just need a brush. You can paint just as you are right now, without preparing yourself in any way. You don't need another class, you don't need another technique, you don't need another idea. There is not any special state you have to be in. The important thing is to start; the rest will take care of itself.

You are ready to paint standing in front of a white sheet of paper tacked to the wall, roughly twenty by twenty-six inches in dimension. At your side you have a set of paints, arranged so that a dozen or more colors are open and waiting. Your brushes, their tips moistened with water, are ready to be taken in hand. You have a few jars of water to rinse your brushes between colors, some tissues, and good light.

How do you begin? Which size brush do you feel attracted to? Do you gravitate toward a small one or a large one? Do you feel tempted to pick up a brush with a fine tip or a thick one? How do you recognize these signals within yourself?

Take a brush and make sure to give it a good drink of water. If the brush is wet it will absorb the paint deeply into

its bristles. A dry brush will not flow smoothly over the paper.

Which color would you dip the brush in right now if you didn't hesitate? The pink . . . the purple . . . the blue? If you listen inside, the brush will want to run toward a color. What you really need and want is very close, and the brush goes to it quickly if you don't think.

Take a color. They are all good choices—don't wait. Dip the moist brush in the paint and feel the anticipation. If no color calls to you, take the first one you see. It is important to just get started.

But you say you have nothing to start with? Then start with nothing. When you start with nothing, you start with yourself. When nothing is planned you have only your own feeling with which to begin. Is that nothing or is that everything? If you want to explore, to move with your intuition, you must get used to not knowing where you are going. There is great freedom there.

As children we were taught how to do everything: how to read, how to study, how to be polite. We have been bombarded with the right way to do things. So now we are approaching art and we think we should know how to do it. Yet art is one thing that we should not know how to do! Art *is* the place not to know.

To create is to move into the unknown—to move into the mystery of yourself, to have feeling, to awaken buried perceptions, to be alive and free without worrying about the result. But the mind is conditioned to think it wants a nice

painting, a nice tree, beautiful scenery. No! Maybe you want monsters. Maybe you want chaos, maybe you want a mess. Maybe it will feel really good to paint an ugly painting. Maybe that would open your being much more than a masterpiece.

So you have the brush ready to paint. Do you go to the middle of the paper or do you go to the side? To the left, to the right—where does the brush want to go? It might want the center, it might want the corner; you go there. You let the brush move how it wants to move: in a circular motion, in a straight line, in a long flowing movement, in short splotches. What gesture does the arm want to make? What feels good to the hand? Do thick lines feel good, or are fine, delicate strokes more satisfying? Do you want to make a little scribble or a big blob or a shape?

If you want to make an image, paint it. You don't have to know how to form an image in order to do it. This is very important. If you have the urge to paint a person, a tree, a bird, you don't need training. You just do like a child and invent it.

Is there anything children don't know how to paint? Look at four-year-olds. They paint the most complex things . . . their houses . . . their parents . . . a bridge . . . a school . . . a fire truck. You might not see that it's a fire truck, but they paint it anyway. They don't care if you recognize it or not, they just enjoy it. Can you treat yourself the same way? You have the right to paint anything you want, even if people don't recognize what it is.

What will happen when you begin to paint spontane-
ously? Are you going to judge your work? Let's say you are
enjoying painting with your pink or your purple, and all of a
sudden the critic shows up. "Pink? . . . Why pink? You
should have taken orange. You shouldn't have painted an
image. . . . What does it mean about you? . . . How good
are you going to be? . . . It's too thick. . . . It's too
thin. . . . This color doesn't fit with the other one. . . .
You are doing it wrong. . . . You are putting too
much. . . ." The mind thinks it knows better what you
should be doing. It has an agenda, consciously or uncon-
sciously. Can you keep your freedom if these judgmental
voices say you shouldn't do what you are doing? Can you
still paint spontaneously, or are you going to be the slave of
your critic?

You might think it's not meaningful enough to do this—
just to paint some marks or lines or a strange image. But
then you don't realize yet how powerful it is to paint purely
from intuition. When you are moving spontaneously, you are
discovering the true gesture of creation within yourself, a
gesture that will continue to grow and bloom as you continue
painting.

When you paint in this way it is not important to show
your work to other people. In fact, it may be important *not* to
show it! Painting for process is the visual equivalent of jour-
nal writing, done not for the sake of being seen or published,
but purely for the telling itself. You may show your work or
not show it—you leave that decision to the future. Now,

when you are painting, it is completely private—just for yourself.

This is the purpose of painting for process. It takes you back to a more natural way to sense yourself, to be yourself. It makes you sensitive and alert to the habit of judging and shows you how inappropriate it is. It reveals boredom as an avoidance and fear of feeling.

Its transforming power comes like a strong wind from outside, cleansing you, slowly taming you, getting you used to the intensity of the life flow. It is extraordinary to see how the discovery of one single free stroke of paint can fill you with such joy and amazement.

the myth
of inspiration

Wherever you are is the entry point!

—KABIR

Who does not feel the tingle of excitement at the prospect of painting? Paint is sensuous. Its rich, vibrant colors and its yielding smoothness make you want to taste the delicious enjoyment of applying it to paper. To stand before the white void with a rich spectrum of colors and brushes is one of the most exciting experiences— unfulfilled potential permeates the space between you and the untouched surface.

The brushes beckon to you. Their soft ends invite you to give them a full draught of rich paint. You know that an

original gesture is about to take place, a journey begun that will lead you to unknown lands.

Creation is a response. Do you need a special inspiration to respond? Isn't it possible to respond to anything? When you approach your white paper you might bring moods, states of feeling, problems, and physical discomforts that do not appear conducive to painting.

"I don't feel like painting. I'm not inspired. I don't feel creative today," are sentiments often felt, if not voiced. The belief that we need to be in a special state to create is deeply ingrained conditioning.

I often meet artists who tell me that they have not been inspired for two or five or twenty years! They are waiting to arrive at that special state. They think creation is confined to a certain range of feelings or an inspired mood. Could they not instantly pick up a brush and face the state they are in and use it? Creativity would be very limited if it could exist only in rare circumstances. There is energy and creative potential in *all* states. As long as life is there, the potential is full.

Wherever you are is the entry point. To do the simple thing with integrity—a point, a line, a scribble, a rough image—is the most creative response you can make. Instead of struggling and forcing something special to happen, you do what you can do. And that is already enormous, because it's a gesture that comes entirely from within, without yielding to the pressures of how you should do it and what it should look like.

Creation is never about changing yourself; it is about meeting yourself, probing deep into your own core. Creation wants only to fulfill your deepest desire: to know and accept yourself as you are. There are no conditions, no invitations to show at the door. You are at the door and your brush is the key. Nothing is a mistake, everything is an extension of your being. You go into what is there, you discover the courage to face what exists. You step into the middle of yourself and move from there.

"If you wait for inspiration, you may wait a long time," I tell my students. "The more you wait, the more you think and get entangled in the tight net of success and failure. You do not need an idea to paint, you need only a brush. If you do not know what to do, just paint!"

you are lucky
if you don't
know how
to paint!

*O*ften someone responds anxiously to what I say with a comment such as, "I hear what you're saying but my biggest fear is that I won't be able to paint something when I try, so I'm afraid even to start."

But you are lucky if you don't know how to paint! Say you have a spontaneous urge to paint a person, but you have never done it before. Perhaps you have never painted at all, or have just experimented with colors and abstract shapes. As you touch the white surface with your brush you have no

idea of proportion, curve, depth. Good! You are lucky, be-
cause you will have to invent.

There are two options. One, you visualize in detail and
try to reproduce what you see in your head, like copying a
photograph. This is boring and tedious work, no life in it. Or
two, you invent as you go, by responding to your intuition
from moment to moment.

Without technique you are at an advantage. You won't
have to unlearn patterns and stereotypes, you will have to
resense and re-create everything. Every image and shape
will come out fresh, real, alive. Your technique will evolve
by itself as contact with the feeling develops. This is what
even the most experienced artist strives to do.

Perhaps you start with an outline of a body. Does the
brush want to paint it long or large or crooked? You go
slowly, carefully, sensuously. You feel inch by inch as you
trace the head. Would the neck bend toward the earth or
stretch to the sky? You follow the spontaneous, the momen-
tary caprice of your hand. Is the shoulder smooth or bumpy?
You don't need to paint an exact replica of a body; you
follow your feelings.

Step by step you invent, responding to the inner urge as
if the brush were guiding you. No resistance, no control. In
that instant there is harmony between you and your work.
You watch in surprise as the painting is born under your
hand. It is amazingly different from anything you could have
thought of or planned. You will probably end up loving it,
but if you don't, so what? You used your creative power

without falling into the pit of concepts; you remained free
and authentic.

How lucky you are!

*If you are reluctant to start a painting, ask yourself: What would I
do if I didn't have to worry about the way it looked?*

do I have talent?

M. C.

I laugh when I hear the fish in the water is thirsty.

—KABIR

When I was quite young, I knew I wanted to be an artist—without any doubt it was my calling. Yet the dark clouds of uncertainty hovered around me for many years as I tried to answer an impossible question: "Do I have talent?"

Talent is not a gift given to only a few. Talent is like the sun shining outside the window: it is there for all of us—all you have to do is pull back the curtains and let it in. Talent comes from openness, integrity, simplicity, and the courage to feel and take risks. It is part of being human.

We live in a time in which most people believe there is not much inside them, only what teachers, parents, and others have put there. We are taught to ingest ideas and information, and then, after we have accumulated enough, we are told that we will be able to create. By believing this, we narrow ourselves and miss the vast movement that knocks at the doors of our psyches. This is a grave misunderstanding, because to be creative we don't need to add anything. What we are is enough.

"I never thought I could paint! I never thought I could come up with something like that!" I often hear people marvel at the miracle of their rediscovered creativity and how available it is. What took thirty, forty, or fifty years to be conditioned and repressed can be revived in a relatively short time, because your whole being wants it, and asks to be itself again. Within a few hours or days you can start to feel the stirring, the awakening of the hidden longing, the urge to manifest through creation.

To discover that you can paint without special talent is a great revelation. An endless stream runs through you, enough to paint for lifetimes. Talent is universal. You can dip into that source to your heart's content. Everyone is good at what comes to them spontaneously. If nothing is put in your way, talent will meet you there.

the
right image

Many people think they need to find the right image in order to paint, the one that will express all the uniqueness and subtlety of their hearts and minds.

The right image is just an idea, a projection. Creation is interested in the unborn. The painter is like a gardener, handling the seeds, not producing them or making them perfect. So how do you know which is the right seed?

The seed that finds its way to your garden is the right seed. On its way, the seed might give you a faint sign or a bold one. You might feel it in your body, in your breath, your

heartbeat, your belly, the moisture of your hand. It is energy moving in you. If you push it aside, it will come back again and again until you place it in the ground to grow.

However you begin, trust that the next step will come. Let the unexpected guide you. Every stroke will invite another one. If an image attracts you before you start, welcome it. But always remember that you cannot know how it will grow. It will appear in its fullness only as you paint it.

Just put your feet on the path and walk to the end. No matter how you start, a movement will arise from there and guide you to what you really need.

If you are waiting for the right image, think about this: What would you paint if you were not trying to impress anybody with your result?

if it's already painted in your head, why paint it?

"I want to paint a beautiful vision I had during my meditation," Cathy said as she arrived at the studio. She started with great excitement, following the vision that was fresh a few hours ago, but now only a memory. The idea of the finished product triggered her energy, but as time went by she slowed down, hesitated, corrected, and stared at her painting, constantly comparing it to the model in her mind. After a couple of hours she was tired and not sure she liked what she had done. In the depth of her being nothing had moved: the passion sat still, unchallenged, her power unused.

Sometimes we are set on painting visions, statements, or messages for the world. How can you possibly plan not only

the subject of the painting, but every detail in it? When you dream, you do not come out of the dream to orchestrate events. The dream images reveal themselves, unfolding at their own pace, the conscious mind in abeyance. When you create in painting, the same image maker is functioning. Not only does it not need your help, but when forced to follow an agenda, it shuts off and dies.

Pure creation does not suffer any limitation or frame. If you begin with an image, use it as a starting point only, inventing the rest of the painting as you go along. To create is to respond to the whole of life as it pushes through you. If you have already planned and designed your painting in your head, why bother to paint it again? It's already done. Painting it will only be technical and tedious work, with very little room for intuition. It will be focused totally upon result, not process.

The fascination of the vision might linger, but it is imperative that you let go of it and move on to the demands of the moment. A work that does not have this spontaneity will lack the miraculous and fascinating essence of life, leaving you unsatisfied.

If you find yourself trying to reproduce what you see in your mind, ask yourself: What would I do if I were not afraid to be free?

be careful, they might teach you something!

There is so much beauty in painting an image or a shape for the first time! I am always moved when I witness that special moment where the body, mind, and heart join in one action. I see then the creative force molding its work as simply or boldly as it must, daring unthinkable proportions and surprising colors. How alive is that which is totally original, perfectly authentic! So many technically skilled paintings have no life in them.

Every so often, a student asks, "I'm thinking of taking a class in technique. Do you think it's a good idea?"

"To meet your passion you will have to transcend every-thing you know, technique and all. But do not take my word for it. Go there and find out what it offers, judge by the fruit. But be careful, they might teach you something!"

At a certain point you must make a choice in painting between the process and the product. There is a tendency to have one foot on each side: "I want to paint for the explora-tion and the freedom, but I also want to do it skillfully, and to have it be recognized. I'm going to let myself do anything I want, but later I will do a nice painting." This compromise is preventing the tool of painting from giving you all its power.

You cannot serve two masters. You cannot embrace product and process at the same time. If you paint freely, you will most likely end up loving what you do because of your intimacy with it, but in the meantime it is necessary that you let go and surrender. You do not need an incentive. The process is enough.

Most of us wish to discover an insatiable passion to create, but meanwhile, if a small unexpected color or shape appears against our desire, we get very upset, judgmental, protective. Our wish for intensity is often just a belief. What we really want is control, to be decision makers. We have to know where we are going. Chaining ourselves to rules, ideas, and preferences, we wonder why we can't fly.

To meet your passion you must jump naked into the deep waters of the unknown. It is an act of love and trust. You paint what is given to you, as it comes, never avoiding,

postponing, or bargaining. You listen carefully inside, entering the mystery, moving toward the real, learning to be where you are.

Ask yourself, What do I really want? If you want a technically pleasing painting, then work for it; you might get it. But don't fool yourself: this won't bring you closer to the aliveness you long for. Passion is elsewhere; it has nothing to do with the result, only with the doing.

the wisdom of
the child

If the Angel
deigns to come
it will be because
you have convinced
her, not by tears but
by your humble resolve to be always
beginning: to be a
beginner.

—RILKE

*J*ames, a middle-aged man, a beginner at painting, was very tight. All the muscles and nerves in his body seemed to be fighting a mysterious enemy that arose when he picked up the brush. His breathing was shallow, his eyes absent, his mental activity was going full speed. He poured out hundreds of thoughts and conclusions he had made about the process and why it could not work for him.

Instead of discussing his innumerable concerns, I said, "Let's try something. Why don't you take one of the big brushes and scribble for a few minutes?"

James was startled by my suggestion. All of his adult life he had been in control of his actions, and he had carefully avoided any unplanned activity. I had him dip a big brush in the paint and practically had to force him to touch the paper with it. He did so with obvious displeasure and some condescension.

"Let your arm go, follow your desire, let the brush play. This is not a painting, it is just an exercise to relax. Don't take it so seriously."

It was very hard for him to do this. He was holding the very end of the brush, standing as far away as he could from the place of sacrilege.

Scribbling can be appropriate for reconnecting with ourselves when we are caught in a mental pattern concerning beauty or meaning or what we should do next. Young children scribble before they paint. It is the most primitive and pure gesture, unconcerned with result and meaning. It is tapping into the source again, remembering the freedom of the beginning.

Soon James was feeling some emotion stirred by his meaningless strokes. He was losing his grip on control, his defenses were crumbling.

"Don't stop," I told him urgently. "No dead time." For as soon as I moved away from him, he stood still and pondered. I could hear his loud thoughts across the room.

"You can't afford to stop, you will lose your energy," I urged him. "Keep moving, and the faster, the better; the faster you paint, the less you will think." Finally James

started to relax, as his brush found places without planning, places without reason.

"It feels good to do," he said, "but I hate looking at it."

"Don't look," I answered.

The habits of the intellect are like spoiled children; they try to maintain their power ruthlessly, by making what we do seem ridiculous. I can't help thinking of little James at four or five years of age, how he was taught what to do and how to do it, how to please adults. I can see the impact and pressure of reward and punishment on his young mind. I can see the grown-up world killing in him the freedom to play, to create in his own way; then the birth of anxiety by trying to be good without ever being good enough, and then, at last, giving up the integrity of his feeling so he could fit into the world more easily. He had been cheated of the joy of creating, and the habits had hardened with age.

"Keep going, James, you can't stop," I said.

"There's no more room."

"There is always enough room, don't stop."

"But I put my brush anywhere, it doesn't make any sense."

"That's right, that is what you think. Don't stop. It's going well, it knows what it's doing. Trust for a little while."

I stayed there for ten minutes more, until his gesture became loose and free, his mind quiet. Painting quickly without thinking had released tensions that were impeding

his creative flow. I had seen this happen many times, but whenever it did, my whole being rejoiced, as if I were watching a dark curtain lifting. Something was being born, a breath of fresh air was floating around the room, the beginning of joy.

If you feel tense in front of your paper, put a generous amount of paint on a hard brush and scribble. It is a pure action that serves to open up the movement of the arm and hand. Painting without caring about the result stimulates new energies within and prepares the ground for the next step.

chaos,
the soil
of creation

I put in my pictures everything I like.
So much the worse for the things—
they have to get along with one another.

<div align="right">

—PICASSO

</div>

*J*ulia grabbed my arm as soon as the lunch break was over. "I've made such a big mess, it is all chaos! Everything is so fragmented and disconnected, there's no defining statement at all."

I stepped into the studio to look at this big mess. Her painting was covered with all sorts of lively strokes of color intermingled with images of animals, people, trees, and houses. I could see that she had enjoyed herself immensely.

I love to see chaos flower in a painting. It can emerge

only from some recovered freedom, announcing a surrender to intuition. To paint chaos is to embrace all levels of expression at once without judgment. But for some reason we think of chaos as something undesirable.

Julia asked, "How am I going to tie the whole painting together? If I don't make it into something coherent I'll feel terrible!" She thought that she couldn't get away with freedom, that she must chain her painting, that the outcome had to be sensible, reasonable, ordered.

Inconsistency in a painting does not mean anything is wrong with you or your work. It shows only that a myriad of perceptions and feelings are trying to reach the birth canal of your creativity all at once. We paint chaos when our work does not pass through the mesh, the filtering process of the conscious mind. As we face the creative void and enter the moment without prejudice or expectation, many images and shapes may rise to the surface from the subconscious mind. Some are timid, some are bold, and all harbor different proportions and qualities seemingly unrelated to one another. They carry a broad spectrum of feelings and impressions that do not seem to make sense. And yet this mixture of forms and colors is the entry point to the inner state. It is expression without manipulation, a doorway to the unknown.

Chaos is the soil of creation. It plows the ground of intuition, preparing it to receive the seeds that wait in secret

places for a fertile home. There is no need to force shapes to connect in order to make a coherent statement. This will be a betrayal of your intuition, and will lead only to control and loss of energy. Without chaos, nothing will grow.

beauty

"I want a nice painting," Brenda said, as if a nice painting would open the door to happiness. A nice painting is a relative statement that will get filed in the storeroom of concepts, where it will be evaluated, labeled, and kept as a point of reference, an illusory proof of who Brenda thinks she is. A mummified object it will become, like a stuffed bird that decorates a living room. Must we hold and tag all beauty and confine it in a cage? What about the beauty of the wild space where nothing is yet born . . . the call of the void, the beat of a sensitive heart, the light trem-

bling of the hand that puts the first mark on an empty space, leaving all possibilities open, not hiding, not asking, not pretending, like a womb waiting for the child to come? What about the great beauty of forgetting oneself?

"If you don't create for process you give away your time, your life," I told Brenda. "You can spend hours painting for the result. For what? For the thought of somebody saying it's nice, or for you to decide whether or not it's good to look at? The fulfillment is in the doing. Then it does not matter what anyone says, you already have your reward. Do you want to sell your life for a painting?"

"But I need the result, it gives me a feeling of satisfaction," Brenda said. "Look!" She pulled a beautiful emerald green silk scarf from her handbag.

"I loved the process of making it and I love having it to look at and enjoy. For me, it is part of creation to have something left; it is very important." She caressed her beloved scarf, pained to think that its worth could be challenged.

"I do understand what you mean, I do," I said. "It is fulfilling to have a result, to have something you can identify with, something you can use and enjoy. It gives you a sense of worth, it brings pride and contentment. It pays you for the time and materials you put into the project."

Craftsmanship is like that: you care for the product, you want it right. Your furniture must be harmonious and efficient, your pottery practical and light of design, your scarf

soft and pleasing to look at. It is a wonderful and necessary activity to create beautiful things, to be surrounded by objects that are comforting to the eyes and the soul. And yet it is creation within limits, for there is a goal in mind: a product to use in your home or exchange for money.

How can any sense of personal preference be compared to beauty itself? It is as a candle is to the sun. Beauty is in the honest brushstroke that manifests without choice. It thrives on life. No aesthetic concept can replace what is authentic. To create is to recognize that real beauty is found only in following your truth, wherever it leads, and that no harmony can be found outside it.

If you are afraid of not painting a beautiful painting, ask yourself: What would I paint if no one were going to see what I do?

the "I want"

"I want a softer color," said Sharon, upset by the strong red she had used.

"I don't want that sad expression on the woman's face," said someone else.

"I want this tree to disappear."

"I don't want this dark color."

"I want a more spiritual painting."

"I want the painting to show more life."

"I want . . . I want . . . I want . . ." The echoes of "I want" and "I don't want" fill the room.

Why do you make your desires so important? When I tell people that what they want is irrelevant, they give me a strange look, as if to say, "Are you crazy? What else is there?"

There is much else! There is what you need—all that which is pushing from inside to be born, all that you may think is too strong, too childish, too different, unreasonable, or strange. Under the superficial "I want" lie all the spontaneous urges to paint, and they require your attention and your honesty.

To create is to be alive. Why force the fruit of your work in a certain direction? It is like commanding an apple tree to grow pears and then being disappointed when it does not. Is it so difficult to welcome the natural fruits that have absorbed the sun, the rain, the fresh mornings, and chilly nights, as was intended?

It's not that you shouldn't want anything, but if you are going to want, go for it and *really* want. Not just a nice painting, not just a little color, but the whole thing—the whole contact, the whole surrender and embrace.

Creation offers a wonderful opportunity to break away from the monotony of your little wants, to open the door to the vast world outside your mental projections. So, want! Just beware of wanting too little.

just play

It is not because things are difficult
that we do not dare,
it is because we do
not dare
that things are difficult.

—SENECA

Hannah was serious. She wanted to find out about the process; she thought it made a lot of sense and was right for her. She eagerly set to work. Soon she was preparing and explaining to herself every stroke:

"This is a free stroke; I wouldn't have done it if it weren't free.

"I shouldn't be caught in the aesthetic, so I will paint what seems ugly here.

"To paint this will be too consistent, so I won't do it.

"I am caught in the meaning now so I have to do something absurd."

By wanting so much to be free, she had created a new technique for herself and was bound by its rules. She was controlling her painting and feeling more and more agitated about not getting it right. Her work had slowed down dramatically and she stood for long periods of time looking at it, trying to figure it out. I could see she was ready to listen to any suggestion, yet I knew nothing of that sort would help. She had already tried too hard.

"Don't make it so important," I said. "Just play."

"I can't," she said, "I'm too controlled." It was true: she was a responsible woman, she had a good, quick, analytical mind, and she was overusing it. The child in her seemed absent.

"If you were five years old, what would you paint?" I asked.

"A little girl."

"Paint with the freedom of a child." I wanted her to rediscover the simple language, for every stroke had become too complex.

A few minutes later she had made a childlike painting of a little girl wearing a colorful dress and a bow in her hair.

"I want to be finished," she said anxiously. "It is too silly, too stupid." The fear of being ridiculous was very strong.

"Don't give up now," I said. "You will jump back into your old patterns."

"There's no meaning in it," she said, longing for sophisticated symbols.

Play for her was a waste of time, silliness reserved for unevolved beings. And yet she was struck by how pleasing it was to do it, a power she had not suspected was there. So she painted a dark brown ground and a sky and a red flower with roots and later on a bright yellow sun. She was thrilled and disturbed. How could she ever fit this into her life? And yet she had to admit it was the best time she'd had in days of painting. In the midst of turmoil she had touched a fresh source.

Why do we make our work so dramatically important? Of course it is unique and special if it is honest, but why identify with it, why squeeze thoughts out of it until it becomes as dry as a pressed flower? Painting is a simple gesture, a little red, a trace of blue, a line, an image, a dot, step by step going toward oneself, listening to the inner voice. Can we paint for the joy of freedom alone? Or do we think we are so stupid or ugly that we cannot trust our spontaneity? Could life have forgotten to give us a heart, a soul, and feelings?

Sometimes people think that to play is to purposely do something silly, and they search for something that fits this definition. Once, when I told a student to play, she painted a pink elephant with a strawberry in its mouth.

"I'm bored with playing," she said after a while.

"You didn't play," I said. "You planned your painting; it had to fit your concept of play. It became an intellectual exercise, not a spontaneous expression. Play is innocent, unexpected. If you could do anything right now, what would it be?"

Her eyes flared. "I would paint a huge dragon, spitting fire," she said, surprised at her display of anger. "Yes, I could do that."

A connection had been made inside her, the image was born directly. To play is to listen to the imperative inner force that wants to take form and be acted out without reason. It is the joyful, spontaneous expression of one's self. The inner force materializes the feeling and perception without planning or effort. That is what play is.

If you are planning instead of playing, think about this:
What would you paint if it didn't have to fit?

pick only
ripe apples

Easy is right. Begin right
And you are easy.
Continue easy and you are right.
The right way to go easy
Is to forget the right way
And forget that the going is easy.

—CHUANG TZU

lizabeth was delighted as she portrayed a dancing woman on a double sheet of paper. Half an hour later I found her painting tall buildings, streets, and cars around the figure. She looked bored and seemed to be falling asleep.

I stopped her in the middle of an indifferent brushstroke and asked, "What would be the easiest thing for you to do right now?"

"Easiest?" she repeated. "I've been working very hard! I thought I should not do what was too easy, so I was looking

for something more demanding." The beginning of a smile appeared on her face. "I suppose the easiest thing would be to put some precious stones on the dancer's belt and a silver comb in her hair."

Elizabeth thought she had to place her dancer in a context. But it was a burden to have to paint buildings and cars when what she was really attracted to were jeweled ornaments.

To keep your process flowing, to feel the enjoyment of creation, you first need to go where it is easy. Easy means ripe. Go where you are attracted, whether it be toward a detail or a large shape. While you work on the part that is easy, other parts will mature in you, and they will be ready and waiting. You move step by step, from the easiest to the easiest. It is never tedious or tiring because there is no need to force anything. Depth resides more in surrendering to spontaneity than in hardworking struggle.

Your painting is like an apple tree. If you want to eat its fruit, look for a ripe one, one that drops into your hand when you touch it. Look until you find one full of flavor. Do not pick green apples: they taste bitter and will give you a stomachache. Remember: Every apple will be ripe in its time; do not rush it.

awaken your image maker!

ensing what to paint is so simple that we often disregard it. As you stand in front of your painting, what do you feel? Burdened? Light? Overwhelmed by the large space? Sad? Rough and bold? Intricate and detailed? Would it feel good at this moment to make a big scribble? Would a delicate brush appeal to you? Would painting a challenging image, such as a human form, interest you?

Your body knows the answers to these questions at each moment. Once you are free of the limiting idea that you need to know what to do, you can sense directly, allowing all sorts

of spontaneous images to arise. That is the first step. Then perceive these images through your body. Which one has more energy, more juice? Which image brings electricity to your veins as you think of it, which makes your heart beat a little faster?

Dare to follow what your body says and see where it leads you. Make that first step. Your being longs to manifest its uniqueness at all times; it will jump at the opportunity you give it and show you the way. This can only be experienced—words will not take you there.

If you don't know what to listen to, ask yourself: What would I paint if I really let myself feel?

sensing

*H*arper was a big man. He had been involved in strenuous physical activity all his life. You could see that his hand was not used to holding a delicate brush.

"What am I supposed to listen to?" he asked. "You're asking me not to plan the painting and then not to pay attention to what I like or dislike, or even to think about what it means. So how do I proceed?"

Harper was asking an important question. His practical nature had zeroed in on the inevitable dilemma of intuitive

work. If you are not to listen to your ideas of what should happen or where things should go, and if you are not to trust your personal preferences or interpretations, what is left? What do you listen to?

"Harper, just try picking up a brush and getting started—that may answer some of your questions," I said, hoping his reasoning would diminish as he went along.

"How do I pick up a brush if I don't know which color to choose?"

"If you looked at the painting table right now," I said, turning him around to see the paints, "and you had to choose a color in two seconds, which one would you take?"

"I would take the red, but that's just because you pressed me, it was really quite random."

"Let's take the red and see what happens," I said. He took a great blob of red paint on his brush and stood facing the white sheet of paper.

"Now what do I do with it?" he asked with growing impatience. "Nothing calls me."

"There is always an urge to move to a particular place and in a particular way, if you listen," I answered. "Don't wait for your mind to block you again. Act—and the rest will follow."

Harper pushed his brush onto the paper and made a thick red blob on one side, and followed this by making a whole series of red blobs over the entire space. Then he stopped.

"How does that feel?" I asked.

"Okay, I guess. What now?"

"Let's take a new piece of paper and get started right away."

Harper repeated the same gesture on the second painting, and then found a place for some blue among the red strokes. He had discovered that there was a way to proceed. Something in him did know which color to take and where to put it. He thought that it was purely random, but he went for the red because it had the most attraction for him at that moment, as did the blue in its time.

We have the ability to sense and act directly, without thought. This ability is inherent and instinctual, but has been buried deep by education and acculturation, usually not surfacing except in moments of great stress or perceived danger. Yet it is there if we listen. Its voice may be quieter and less dramatic than the loud clamor of reactions and opinions, but it has an intelligent persistence that can guide us.

It often seems too simple. To dip into a color just because you are attracted to it seems too easy. To feel the presence of an image waiting to be painted is dismissed as fantasy. To feel driven to complete the painting with hundreds of little strokes or dots is labeled compulsion. To repeat an image or a color on another painting is considered redundant. And to like your painting not for its prettiness or its ability to impress, but simply because you had feeling as you did it, is thought to be a waste of time.

Harper was standing in front of his paper, staring in-

tently at a large area that was not yet painted. "I feel something wants to be painted there, but I don't know what," he said. Harper was beginning to sense directly. He felt the call of that open space without his usual defensiveness.

"Let's try something," I said. "Tell me the first thing that comes into your mind as I point to that area. You don't have to paint it—just tell me what it is. This will wake up the image maker."

Harper was now more into playing the game. "I see a big dark horse—or a football field with grandstands—or a range of mountains."

"Now sense yourself," I went on, "and tell me where you feel the most in your body as you stand in front of your painting."

"I feel a heaviness in my feet, and tension in my neck."

"Now look again at that blank space and tell me what comes to you."

"There is a large gray cloud with rain coming from it—and dark thunder shooting out in all directions," he said quickly, showing me the movement of the rain and thunder with his hands.

"If you review all these images you have come up with, and sense them through your body—not according to your preference or your ability to paint them—which has the most energy for you? Which one has a special excitement about it, as if the brush would like to paint it?"

"I want to paint the rain and the thunder," he answered with certainty. Harper quickly painted these new images and then discovered that there were others as well: obscure faces peering out of the cloud and little bodies on the earth below. An hour later he was still painting.

exploring
the unknown

Travelers, there is no path,
paths are made by walking.

—Antonio Machado

Often when I come up to someone standing still in front of a painting, I sense that the person is strongly attracted to a form or image but afraid to paint it. "It would be too stupid," "I could never paint it," or "I would be ashamed to do it," are frequent responses.

Intimations that have come to us and which we have refused often prove to be the key to unlocking the next step in the painting process. We censor ourselves quickly, almost unconsciously, and before we know it we are blocked. We take our judgments as gospel truth without so much as an

inkling of skepticism. "That doesn't belong there," "That would be trite," "I've done that before"—all these assumptions must come under scrutiny.

The spontaneous imagination is often disregarded as inconsequential. It is as if we deem these fleeting inspirations to be frivolous noise. On the contrary, it is the judgments and barriers we erect that are the frivolous noise, not the images that come to us. If you treat your inner life seriously and with respect, you begin to see that there is an intelligence behind the seemingly random suggestions it presents, and that it is in your own best interest to follow them.

If you want to explore the unknown, intuition is your best guide. When intuition passes through you, it has no choice. At every moment it has only one possibility: what needs to be done. Like a flower, it has only one way to grow. The mind, then, does not spend each moment considering possibilities, but rather enjoys watching the garden bloom. Life gives us the seed; the artist's job is to make sure it will grow.

Often I see artists carrying the burden of creation as if they were totally responsible for it, as if every stroke had to come from their choice to paint or not to paint and how to do it, as if every step in their work depended on a personal decision. What a heavy load to carry! When there is choice, there is success and failure and endless opportunities for mistakes. But when you do what needs to be done, simply and wholly, the next step becomes obvious. Beyond mistakes and no mistakes, you are free.

There is nothing more satisfying than to come from that
source, that place that has no opposite because it is a place
of being. When an act of creation springs from intuition, it
flows effortlessly, it has no friction, no argument. All colors
and forms have just one way to be painted: without doubt or
hesitancy. They flow with a rhythm so perfect and precise
that there isn't one color that could have been another one.
When you listen to the voice of intuition it has the perfec-
tion of nature, because it is nature.

*If you think that you have nothing to paint, check carefully to see
whether some images and colors have already come to you
that you censored and conveniently forgot.*

what is ugly?

M. C.

*Let the beauty we love
be what we do.*

—Rumi

One day when I was painting with the children I wanted to paint a twisted oak tree. I dipped into the brown paint with great enthusiasm. But as I moved the brush on the paper I was puzzled to see that my tree did not look like I thought it should. I tried to create a knotty trunk, but it only got fat; I tried to twist the branches, but they curved down to the earth. I kept painting and struggling but nothing seemed to work as I wanted it to. I had to admit that I lacked a sense of color, form, and proportion. Yet inside me the feeling was clear and intense and beautiful—what a contrast!

I looked around the room, where fifteen children were eagerly painting, and every one of them seemed to be doing better than I was. "I can't even paint like a four-year-old," I told myself. "Not only do I have no talent, but everything I do looks ugly." As I indulged in these depressing thoughts, a sweet little girl about seven years old came toward me and stared at my painting with great attention. Then she looked into my eyes and with a burst of feeling declared, "I really love your painting."

I will never forget the impact of her words; she awoke me from a nightmare. Her statement showed me that all judgments are relative and subjective. My painting could be beautiful if it were looked at differently. In an instant I saw and understood all the paralyzing implications of criticism, how it kills innocence and enthusiasm, and most of all how it destroys the power and energy to create. In that moment I felt the old habit of judgment die in me. I knew that creation was very simple, free from success and failure, beauty and ugliness, comment and opinion. Now I could paint.

If the judgment "ugly" persists, try intentionally painting an ugly painting. It can be an effective liberation from the tyranny of good and bad.

the mind
is a thief

*The course of a river
is almost always disapproved of by its source.*

—JEAN COCTEAU

George had just finished painting an image of a man standing alone in a grassy field. "I can't stand what I've done," he said, his face flushed with red. "It looks more like a creature than a person, and anyway, I never could do landscapes—I hate it!"

Judging your work is one of the hardest challenges in the painting process. It is the immediate reaction of a consciousness long bent on protecting itself, and is felt with such conviction that there seems to be no arguing with it. A disheartening judgment is the last resort of a threatened

self-image, and it can attack with the desperation of a cornered animal, endangering your openness and enthusiasm.

"This is trite," George said as he attempted to tear the picture off the wall. "All my paintings look cartoonish. I have the ability of a three-year-old."

"If you can paint like a three-year-old, that is a great compliment," I said. "The work of a child is alive and fresh, just like what you are doing now—except you are looking at it with old eyes."

I wish students could see their paintings through my eyes. A person who has done his or her best, confronted the fear of committing to color and form, and dared to step over the threshold into the unknown will invariably produce something of striking character. This creation cannot be contained within the two-dimensional labels of beautiful/ugly, profound/silly, meaningful/trite, acceptable/unacceptable.

The outcome of a painting has to be viewed on the same ground from which it was created—its aliveness, its energy, its vulnerability—in order to be appreciated. This aliveness resides in the painter's face, in the posture, in the change of feeling, and in the heightened awareness of the moment, as well as on the surface of the painting. The outcome is the whole experience, not just a piece of paper with paint on it.

I suspected that George was afraid of his creativity. Like many people in this situation, he felt exposed and lost, and instinctively turned against himself in self-judgment. It

was safer for him to bemoan his lack of skill than to feel the void that was opened in him as he confronted the blank paper.

What are you afraid of as you face the paper? Of making a mess? Of attempting something that may appear primitive and unsophisticated? Something that might reveal your ineptitude? Are you afraid something dark or foreboding might emerge? Or silly and superficial? Try it and see! You might have all those things inside you. So what? Let them out, paint those frightening demons, see if they really have teeth. You will find out whether they are real or if they dissolve once exposed.

By the end of the workshop, George was forgetting himself for minutes at a time and began to enjoy adding colors and images to his painting. He finally admitted that he actually liked his paintings—not because they deserved it, but because he had done them.

The mind is a thief: it wants to steal your process. So whenever it tells you anything about your painting, remember who is talking.

do not
kill the void

People often start their paintings by filling in the background—the whole surface is covered in a few minutes. They may do this out of habit, fear, learned technique, or convenience. Whatever the reason, not a trace of virgin paper is left. I always witness with apprehension this killing of the void.

The untouched surface has a special power, so much so that it can often intimidate or momentarily paralyze us. Emptiness is a mating call to creation; the void attracts form and embraces it in an act of love. The pure space has a magnetism that reaches deep inside our being and brings

out the best part of us, the part ready to be born. There was nothing . . . then there is something. The void must be treated with respect, entered carefully and slowly. If the void is filled thoughtlessly, its power is destroyed and a precious potential is lost. Covering a new space too quickly, either for reassurance or for practicality, will smother your intuition.

Let yourself rest in the void for a while. Perhaps an impulse will come—say, a little blue area just right of center—and you will start with it. Put the brush in that spot and move slowly. Be sensitive to where the brush wants to move. Follow its lead. It may feel good to continue carefully, to stay in a limited area. Live with the uncertainty of what will appear in the surrounding white space.

Don't jump too quickly! This defeats the purpose of the painting process, which is to put you in a position where you don't know what to do. Let your feelings be free as you continue to paint in the moment, not knowing how to resolve the painting as a whole. It is living with this uncertainty that begins to open the intuitive senses. Hidden levels reveal themselves when you rest quietly in the unknown.

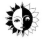

The void is the source of all creation. Your willingness to meet this nothingness without panic is your greatest ally. Let the blank paper challenge you, and see what happens!

abstract forms or concrete images?

n undefinable shape or area of color may allow certain feelings to be expressed that are beyond cognitive understanding. It is important to respect that which looks like nothing. Respect for the abstract form is respect for the mystery, including the unknowable meaning of one's painting.

Annie had just recently started painting and was already feeling the powerful impact of creativity. From the first moment, her brush was free. She did not care about

artistic bias, she wanted the real thing—the truth in cre-
ation.

"I don't know what I'm doing," she said, amazed that
she could enjoy painting so much without having done it
before.

Annie was finding intense fulfillment in painting ab-
stract shapes and forms. She would spend many hours on the
same painting, adding lines, dots, areas of color. When she
listened to the voice of her intuition, that is what came out.

"I love doing what I'm doing, but the other people
around me are painting so many dramatic and striking im-
ages. They're so different from mine—are you sure it's all
right?" she asked.

"Abstract forms carry tremendous strength and can
move your energy in mysterious ways. Recognizable content
is only part of creation, and it is not always needed. You are
obviously doing what is right for you. Look at the way it
focuses your attention for hours on end. You may spend
many days, weeks, or months in the mystery of the un-
formed. As long as you are at peace and interested, you
don't need to question it."

The woman painting next to Annie overheard our con-
versation. "I'm going to paint an abstract painting, too," she
said. "I've always preferred the abstract school."

"An abstract painting is not a goal you set," I cautioned
her. "If an image knocks on the door and demands to enter,
make sure the door is unlocked. Painting without recogniz-

able form is fine. Just be sure you don't do so out of fear of imagery."

Sometimes people decide to create an abstract painting from the start. No images are allowed to appear. This is not natural. How can you know what your painting will need before you begin? When people say they do abstract painting only, it often means they are ripe to explore the dangerous and judgment-prone world of recognizable images.

Imagery carries with it the risk of exposure, of being seen without the veil. Abstract expressions challenge the patterns of familiarity and meaning. Both have their place in the adventure of painting for process. There is no need to define yourself by the label "abstract painter" or "representational painter." You are not a "painter"—you just paint.

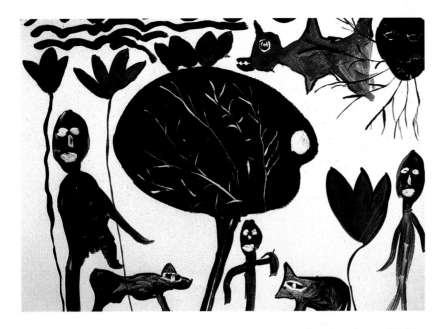

*Painting is just a tool;
it is nothing in itself.
What counts is
how you do it.*

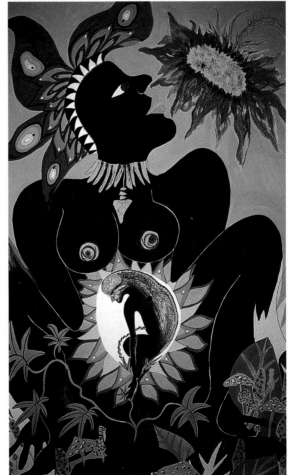

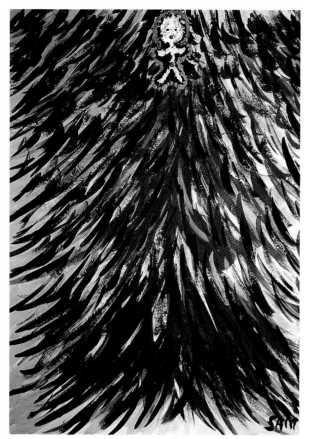

Talent is not a gift given to only a few; it is universal. Talent comes out of openness, integrity, simplicity, and the courage to feel and take risks.

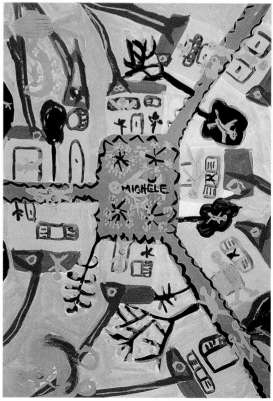

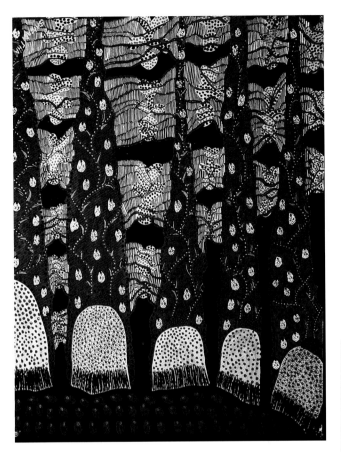

It is extraordinary to see how much the discovery of one single free stroke of paint can fill you with such joy and amazement.

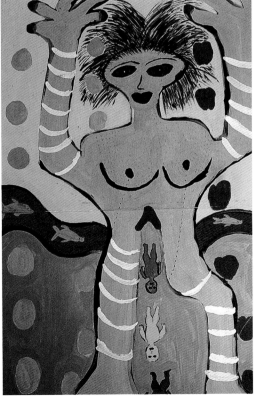

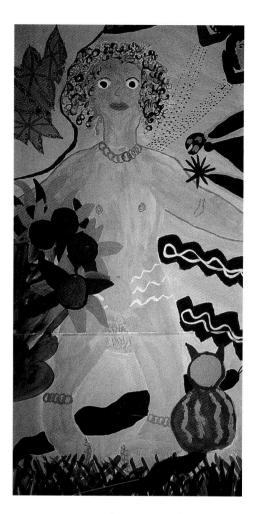

*To do the simple thing
with integrity—
a point, a line,
a scribble,
a rough image—
is the most creative
response you can make.*

The visible painting is just the echo of a much greater process. What is reflected in the forms, images, and colors are the by-products of a journey that has taken place on an inner landscape.

To create is to recognize that real beauty is found only in the honest gesture, wherever it leads, and that no harmony can be found outside it.

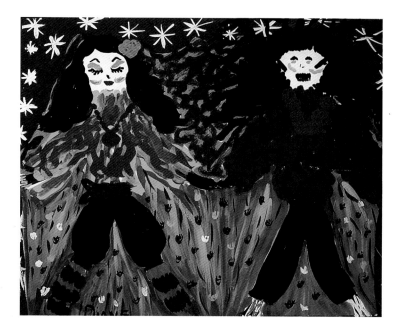

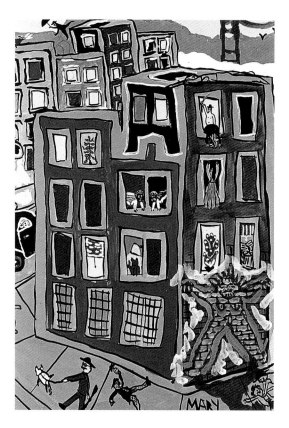

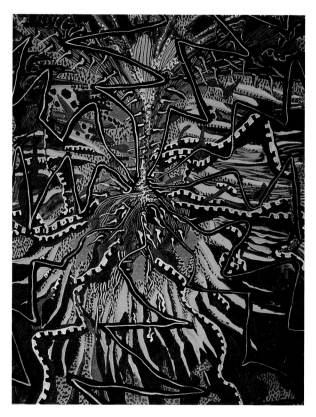

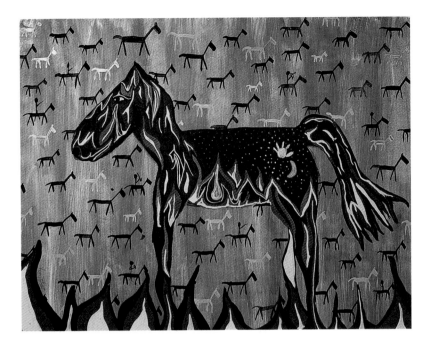

*W*hen you have done
your best, confronted your
fear of committing to color
and form, and dared to
step over the threshold
into the unknown,
you will invariably find
your own voice.

*The content of the painting is
as a ripple on the surface of the ocean.
The deep currents of the water,
the constant tide, the rhythm that carries
you while you paint, this is where
the real meaning is.*

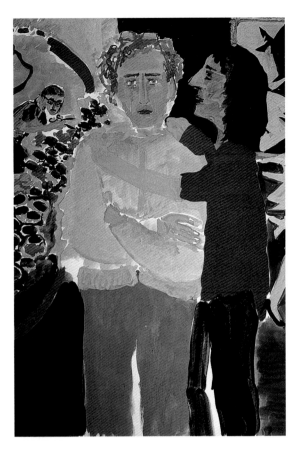

*O*nce you are free of the limiting idea that you need to preconceive your painting, you can sense directly, allowing all sorts of spontaneous images to arise.

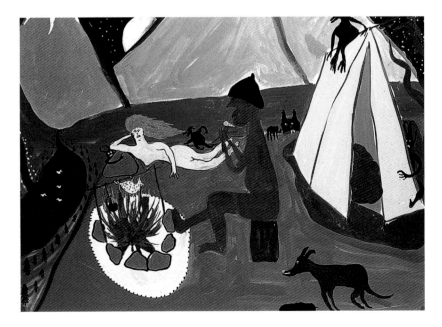

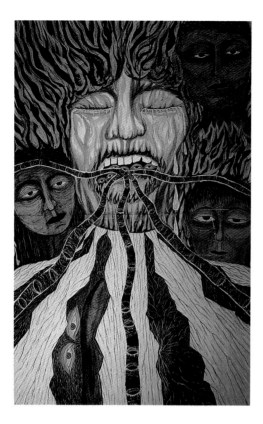

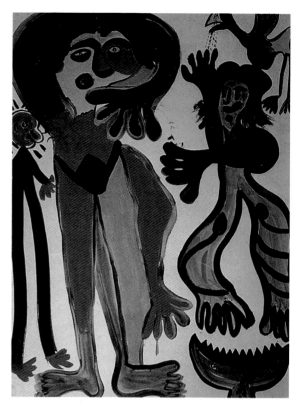

There is an intelligence behind the seemingly random nature of your spontaneous images and forms, and it deserves your trust.

When *you dream, you do not*
come out of the dream to
orchestrate events. The dream
images reveal themselves,
unfolding at their own pace,
the conscious mind in abeyance.
When you create in painting,
the same image maker
is functioning.

When done spontaneously, the painting of a fearful image from the deep recesses of the psyche is a powerful event.

*W*hen you begin to lift the veils of censorship and repression in painting, a great deal of energy is unleashed. This may manifest as sexual imagery.

The creative force is like a beam of light; one moment it focuses on a flower or a god, the next moment on the underworld. Nothing is too dark or too sacred for it.

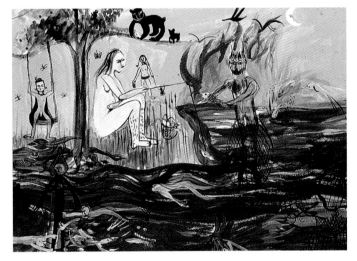

*L*ike a broom sweeping away dust and residue, creation acts as a purification of what has accumulated in the life of the psyche.

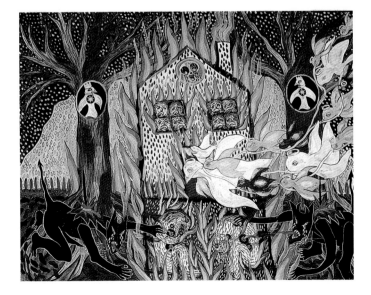

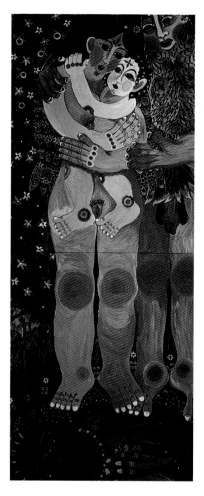

The forms and images that we have inside are authentic. When we let them manifest in their own unique way, we are in touch with something beyond ourselves.

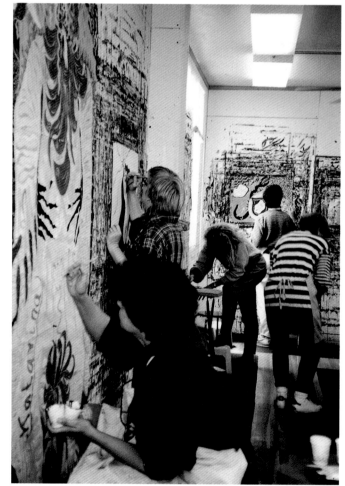

don't
trample
the flowers

I was startled. Peter was covering his painting with very thick orange circles. He had worked for two full days on a mountain scene. I had watched the great care and attention he had put into it, the delight he took in every detail. Now his orange circles were covering the little people climbing slopes, the wild goats, the cluster of pine trees.

"What's happening?" I asked.

"Oh, I hesitated before I started all these circles, but I was tense and now it feels really good to paint them," Peter answered.

Intuition will never ask for such blunt destruction of what it has just given you. If you want to cover up or destroy an image, be very suspicious—it is most likely a reaction to the emergence of a new feeling. There are other ways to move with this intensity and still respect what has been done.

It did not take long for Peter to lose his energy. After a few moments of release, disappointment overtook him.

"What else could you have done with the same strong feeling?" I asked. "What other options did you have?"

He looked into himself for a few moments, and then said with a look of surprise: "I could have started a fire in the trees!"

"Yes," I said, "that would have taken into account what was there *and* carried the integrity of your feeling. I think you just learned something. A gardener never tramples the flowers he has planted."

creative destruction

*I*t is important to learn to use destructive energy in a creative way; if you do not, it will turn against you. Actual destruction brings a few seconds of pleasure, and this is why it is so tempting. But it leaves you with a bitter taste, a sense of failure, for you have denied your feelings and disrespected your work. Handling a destructive urge properly brings a sense of power, for then you feel that anything can be used and expressed, no matter how dark, and then nothing can stop you from creating.

"Are you frustrated?" I asked Abbie. It is often hard to

admit that we are upset, not interested in what we are doing, and fighting to stay on the track of good behavior. Often the first answer to my question will be, "No, I'm okay, I'm doing fine." This is frequently only a wish, a desire to convince ourselves. We cannot play games with the painting process. The moment we don't do what we need to do, frustration arises. The intelligence of our organism responds to the pressure of pretending that we feel something other than what we feel, or simply refusing to feel it. This is the birth of frustration, as the acceptable fights the unacceptable and the expected fights the actual.

Frustration is an extremely valuable tool. It is a safety valve designed to wake you up. When you are sidetracked in the process, tension rises in the body and warns you of the danger of following the imaginary road where everything is stereotyped and dead.

Sensing Abbie's open-mindedness and readiness to explore, I asked her: "If you were totally free in this moment, what would you do?"

"Well . . . I would put some blue here . . . a yellow line here . . ."

"If there were no bad consequences of any sort, if you were really, really free?"

"I would tear up the painting!" she said angrily. "I hate it!"

"Yes," I said. "And what would you do with your brush if you could use the energy that makes you want to tear it up?"

"I would paint over everything with a big brush."

"What color would you use?"

"Black!"

"What else could you do with the black if you did not cover everything?"

"I could outline the figure or accent the clouds."

"No. I am asking if you were using the black *and* your feeling together, what new image would come out of it? To cover the whole painting is a destructive act, but to find an image or shape that carries the feeling of destruction is creative."

"I don't understand," Abbie said.

"You told me you wanted to destroy the painting. Could you do it creatively? Could you use an image that could attack or destroy your painting? Which part would you attack first?"

"Oh, that house," she said, pointing to a blurry image she had been struggling with for a long time.

"What could you do to attack it?"

"It could be struck by lightning!"

Something clicked. Her feeling and action connected, like two electric wires touching. She woke up.

"Oh, I see! I just have to paint what I feel."

To use the energy of violence for creation instead of destruction is a fascinating process. We are afraid we won't be able to contain these intense feelings, that we will start scream-

ing, destroy the painting, or even hurt people if we feel our anger. How little logic there is in that! To react to it in the world wouldn't be good, but to express it, to let it run through us, to give birth to its shapes and colors and follow its evolution, to see its roots, to free it from the cage of the body-mind, how could that be dangerous? If anything is dangerous, it is to not paint it.

When children play they take their trucks and dolls and bump them together. They like to drop things on the floor, and if they make noise, they love it even more. They hit the doll, they attack their parents with a "bang bang." Is there anything wrong with this? If you told them not to do it, they would have to repress part of their being.

Maybe this "bang bang" that we worry about is just a release of pressure, like the cracking of the seed. When a seed sprouts, it's a violent process. The skin breaks and splits in two. Something dies and something is born. Anytime you paint a strong or violent image, you may be expressing that part of yourself that's opening in order to let the new emerge.

feeling
and painting

Scoop up the water and the moon is in your hands;
Hold the flowers and your clothes are scented with them.

—THE GOSPEL ACCORDING TO ZEN

ane beckoned to me as she was about to start a new painting.

"I want to paint my heart," she said.

"What image would that be for you?" I asked.

"Maybe a maze," she said. "Something to show confusion in a relationship. Should I look for an image to portray that?"

"It's all right to have an image before you start," I answered. "But the point is not to portray what you already know. It is not a matter of painting your feelings. It's about

feeling *and* painting. They are very different things. If you paint your feelings, there is a middleman involved: first you must know the feeling, then you have to come up with an image to translate the feeling, and then you have to execute it. That is work, not creation.

"But feeling *and* painting is different. To feel and paint means to let the feeling sink deep into your bones, and then to start from that feeling without having to think about it. Feeling paints itself; it doesn't need you! When you feel in your body, you are living the feeling rather than trying to portray it. Then the feeling finds its own expression without the help of your conscious mind. And it will open other directions that you would never have connected with the original feeling."

"As you were talking, an image came to me," Jane said. "I want to paint a tree with many roots; a dark red tree with green leaves. Just thinking about it makes me happy, but I don't know why."

"That's the key—you don't know why. That's enough of a start, just like that. Don't decide what's in the tree or around the tree. That would be jumping too far ahead, and you would run the risk of becoming too meaningful. Stay in that interval before the mind becomes involved, upstream of knowing too much. That's where the energy is."

To paint with feeling means to not know. An image arises and it stimulates a response in the body—your stomach

lurches, your breathing gets rapid, you experience a myriad of strange sensations. You are surprised by what has appeared, and you do not know what to think. If you keep painting, you stay in not knowing—taking another brush and color, letting yourself be surprised again and again, until the movement itself takes over. You have no goal and therefore nothing to compare it to. The unfolding of the unexpected becomes the energy that drives you. You discover how thirsty you are for exploration without analysis. You feel strangely at home in a place you can't define. You are truly creating.

interpretation vs. insight

The rose laughs at my long looking,
my constantly wondering what
a rose means, and who owns
the rose, whatever it means.

—Rumi

We are all well trained in interpretation. We read meaning into almost everything we do. We think our actions would be pointless if we didn't apply labels to them. It is a radical thing to act without interpreting, to give credence to that which is undefinable. It challenges us in a profound way.

Bobbi was standing in front of her painting of a large woman surrounded on each side by other figures. "I've been painting these same people over and over again in my last paintings," she said, "and I still don't know what they mean.

Every time I start, they reappear, and I feel I have to paint them again, but I don't understand why."

"You may think you want to understand the message of the painting," I answered, "why these people continue to arise and what they mean in your life. And you could come up with some plausible theories to explain them. But to form conclusions about these images will draw them back into your sphere of self-knowledge. Meanwhile, the true purpose of the painting process would be lost. While you are busy defining new issues to work with, the creative force that brought forth these spontaneous images would be pushed into the background—where it usually is. Interpreting your painting stops the creative process. It switches your source of action from a total response to a little part of your mind."

To create is to allow that deeper voice within us to emerge through insight. Spontaneous expression has an expansive intelligence that is nonlinear and nonlogical, much like our dreams. The purpose of the painting process is to unclog this channel of intuitive action and allow it to operate in every aspect of our life. Painting stimulates insight because it brings us to where we are; it keeps us in the moment, facing whatever is there. It moves us out of the claws of concepts, putting us in a place of innocence and vulnerability, a place of wonder. New understanding will always spring from not knowing. Emptying of the brain through painting creates a vacuum that attracts real spontaneous knowledge.

You may be walking down the street and be surprised

by an insight about a relationship. You may notice that you are perceiving things differently and that your habitual response to familiar situations has changed. Awareness of limiting patterns often grows stronger, and with it the ability not to get caught in self-defeating scenarios. These perceptions may occur while you are painting or many days later.

Insight cannot be predicted. To think you need to know what your painting means beyond what comes to you naturally is to disrespect the intuitive part of yourself. There is an order and a rightness to things as they appear, if you let them be. To be present with each new development in the painting and to experience it fully is infinitely more life-changing than any interpretation.

The most interesting thing to paint is what you don't know about yourself. The true meaning of the painting is beyond any story you can expect or imagine.

the
body knows

Be aware of any sudden physical sensations. These can be symptoms of the process at work. They are attempts to involve you with an unknown feeling, and they require loosening of control.

David stood motionless in front of his painting. He had started the image of a large sword—six feet high—the previous week. Then he added a woman with long red hair, clutching the sword from behind. Upon returning, he announced that he was going to add a huge green dragon on

the left. After the dragon's ferocious head took shape, David collapsed on a stool in front of his painting.

"I feel absolutely exhausted," he said. "Maybe I should go take a nap."

"Let's see what this tiredness is all about," I said, helping him up. "Did anything cross your mind in the last few minutes?"

"Yes," David answered, "I had a flash of the dragon's body sweeping across here," as he pointed to the upper area of the painting. "And then the tail seemed to come down and wrap around the woman's body." He suddenly turned crimson and exclaimed, "Oh, *no!* Not that!"

"What are you seeing?" I asked.

"I see the dragon's tail coming up between her legs and penetrating her," he said in disbelief. "Do I have to paint that? Yes I do," he answered in the same breath.

David spent the next two hours forming the dragon's body. He worked with feverish intensity, having forgotten his fatigue and desire to sleep. At the end of class he was still passionately painting, unaware of the time or his surroundings.

Sudden tiredness is highly suspicious when it arises in the midst of the creative act. It generally is a message from the deeper self that something wants to be painted. Consciously we attempt to cruise along as usual, fulfilling our

agenda, leaving everything undisturbed. But just below the surface is another force, one that can surprise us with the strength of its demands. The body does not lie. It is a channel that the thinking process has not been able to obstruct.

A physical reaction can be a direct message from the unconscious. Nausea or dizziness is often a sign that you are relaxing your grip, allowing yourself to open up and feel the potential of the moment. They are not bad indications, and will soon pass. The same is true for pains—a headache, a backache—any mysterious sensation that seems to arise out of nowhere. Feelings are stored in the body. When the intuition is successful in uncovering new perceptions, areas of the body become unlocked.

Janet was slumped on a stool holding her head in her hands. In front of her was a painting of a very large woman wearing a headdress. "I have a splitting headache," she said. "It's been building ever since I started painting an hour ago. I was fine before class. In fact, it started just after I painted all the colors in the headdress. I saw that the woman was an Indian goddess and a symbol of power."

"Is there something you would not want to put in this painting?" I asked.

"Well, there could be a man behind her, painted in black, but he doesn't belong there—this is a painting about female power."

"Had you thought about painting this man before, or did you see him just as I asked?"

"Oh, he came to me a few times, but I really don't want to paint him."

Her comment about the painting symbolizing female power was a tip-off. Her intuition had been blocked by the decision to make a statement about the meaning of her painting. A spontaneous voice was knocking at the door of her imagination, but she was not answering. She had decided the painting was about female power, and a man did not belong there!

"Do you think your headache might have anything to do with blocking something in the painting?" I asked. Tears came to her eyes, and she began to tremble.

"I wanted to feel powerful," she said. "I've been depressed lately; I've been feeling so burdened by my life, I'm just overwhelmed."

"Take the black and let this man emerge," I said. "It's time to let go of the attachment to the painting and begin listening to yourself. You are feeling powerless and overwhelmed, not powerful and in control. Paint with your true feeling, not with what you wish you were feeling."

Janet took the black brush and let a huge male figure appear behind the goddess. The arms stretched all around her body, enclosing her in their grip. A half hour later I returned to find her madly painting flames licking up from below, engulfing the lower parts of their bodies.

"I feel so much better now," she said. "I don't understand why, but my energy has returned and I feel stronger. Maybe the fire is an agent of cleansing. . . ."

"Stop right there," I said. "Do you want another headache?"

if you do not listen to your intuition, it will stop talking to you!

We often erect a red light or a "wrong way" sign in front of spontaneous images as they arise. It is as though every new shape or color has to stand trial before a formal court prior to being allowed to appear on the painting. It is such a strenuous procedure that the images get tired and go on strike, leaving us blank, blocked, without possibilities.

"Are you listening to your intuition?" I asked Beth, who seemed to be struggling with some colors, redoing them, changing them with a critical look. Beth was slow and me-

ticulous. I could see her evaluating every stroke she painted. I watched as she began to paint over the face of a woman.

"It doesn't express what I want," she said.

"Beth, in life, do you change the faces of people you don't like? Is it for you to decide what their expressions should be? Do you still think you are the boss when you create? If you don't respect what has been spontaneously painted, you will lose all joy in the doing. To create is to respond to what you have, not to manipulate it. You could add some color, a small detail, another form to carry more feeling, but to cover up an image is to stop the river. It will feel good for only a couple of seconds before it leaves you dry and empty."

If you do not listen to your intuition, it will stop talking to you. Your intuition is like a sensitive friend. If you question it, censor it, judge it, it gets hurt and becomes silent. When you paint for process, you don't decide what is and is not acceptable. The gift of spontaneous expression has been given to transcend that choice, to open you to what you do not know, cannot predict or expect.

It seems so difficult to give up ambitions in painting, whether they are aesthetic, psychological, or spiritual. Expectations are strong and demanding, while intuition is subtle and always available, waiting patiently for you to turn to it. Oblivious to your prejudices, it guides you toward your-

self and never compromises. The fuels of intuition are integ-
rity and courage. Harmony is its moving force. The expres-
sion of life and truth is its need. No vested interest can
influence it; no limitation can stop it; no pride, ambition, or
fear can control it.

on second thought . . .

I never saw a wild thing
sorry for itself.

—D. H. LAWRENCE

erry was standing transfixed in front of a huge painting of a woman with six outstretched arms. On one of the arms hung a gold bracelet, which stood out starkly against the dark skin. Gerry's enthusiasm had been real when she first painted the image, but now she was unable to continue.

"I'm trying to decide what objects should adorn her other arms. I want each arm to display a different aspect of herself. And now I can't seem to think of anything," she said.

"Let's go back," I said. "What happened after you painted the first bracelet?"

"I was very excited because all of a sudden I saw bracelets on her other arms, too, and even on her ankles. I saw them all over the place! But then I thought I should do something more original so I wouldn't just be repeating myself."

"So your first thought was to put bracelets all over, and then your second thought was to find something more original. Which do you trust more—your first thought or your second thought?"

"Obviously I was trusting my second thought."

"Try going back to your first impulse and see if it is any easier to proceed," I said.

First thoughts spring from that mysterious dimension beyond logic. They come out of nowhere and for no reason. Second thoughts are usually tied to reference points and associations, and they try to accommodate or ameliorate the untamed nature of our first thoughts. First thoughts often seem too simple and straightforward to the sophisticated mind, and we are tempted to dress them up to make them more interesting. Second thoughts are calculating; they want to civilize the primitiveness of our spontaneous urges.

To give birth to the unknown, we must be willing to step out of the way and take what comes, no matter how unacceptable it seems. Our deeper needs are not often served by

following what we think we want or what makes sense. There is an intelligence behind the seemingly random nature of our spontaneous images and forms. It deserves our trust.

Good rules to follow: If it has a reason, be skeptical. If it makes sense, furthers the story, balances the color, or ties the painting together, there is a good chance that it is the voice of control. If it comes uninvited—if it does not fit or make sense—dare it! If you are not sure where it is coming from—your head or your heart—do it anyway. You will learn in the doing.

dark
shadows

"Grab the freedom," I told Robert. "Give it all you can, don't let it go, don't let it sink in the sea of concepts. Paint what comes without censoring, without choosing."

"But spontaneity is too risky for me," Robert said. "I might go crazy, get silly or violent—anything might come out of me!"

Robert was conscious that turbulent waters were raging in-
side him, probably full of dark monsters and unspeakable
fantasies. We are often paralyzed with fear of what we might
find inside if we stopped controlling the outcome of our cre-
ativity. We suspect that all kinds of terrible imagery will
emerge.

It is true that a lot has been stored in the reservoir of
emotional consciousness. All repressed feelings accumulate
inside and become more and more threatening as time goes
on. The error is to ignore them. They may be huge, blood-
thirsty, and glow in the dark, but they are cardboard de-
mons, and they lose their power as soon as they have been
painted. They are dangerous only when kept prisoner, and it
requires lots of energy to keep them locked up and tranquil-
ized. When they appear on the paper, a vibrant energy
floods the body and you feel relieved because you don't have
to stand guard anymore.

"It scares me to paint all this blood," Sheila exclaimed
as she painted a scene of war and carnage.

So what if your expression demands some fantastic or
dramatic or even "unacceptable" images or colors? What is
it to you? Why fear it? Why deny the spontaneous intuition
that brings it? The strong images and strange shapes will be
painted and then will pass, and the next thing will come.

"How did it feel to paint it before you looked at it and
thought about it?" I asked Sheila.

"Great!" she said.

"Don't look at it, then."

When done spontaneously and in its proper time, painting a fearful image from the deep recesses of the psyche is a profound event. Hidden in us is the whole world with all its aspects—its beauty, its love, its thirst to uncover truth. But the dark shadows are also there, quick to respond, and they choose their own time to appear in daylight. When both sides of duality are welcomed and embraced, a balance is established and the fear of demons dissolves.

As the image is born and grows on the white paper, it reveals its qualities, and in doing so, loses its negative power. Its charge melts as it is recognized and reclaimed by manifesting outside the painter. Its expression brings a sense of release, of relaxation, of space, and we become softer, not more violent, as we feared. When judgment and shame are absent, painting dark shadows becomes easy and natural.

If you are frightened of painting your demons, ask yourself:
What would I paint if I let myself go wild?

on
finishing

Sometimes people feel insulted when I ask if they could do more on their painting. "I know it's complete," they say, "I can tell; my painting is finished, *I feel it.*" The mind is so clever. It uses the language of the heart to steal our freedom, it hypnotizes us with words. We confuse feeling in the head with feeling in the heart. Plain liking or preference is not feeling. Desire, impatience, or unwillingness obscures the truth of what is real. Love of product adopts the disguise of an emotion and paralyzes our intuition.

I was standing close to Ingrid, who had an extensive art

background and wanted to dedicate her life to painting. She was insisting that she always knew when she was finished.

"If I keep going I'm going to mess it up. I like it the way it is; I want to keep it this way."

I could see she had learned to assert herself. This confidence was a shell, a prison. She seemed to be struggling with me, but in fact she was struggling with herself. Could she soften, could she doubt? Could she open herself to impersonal knowledge, to intuitive insight?

"You will have to choose between your life expression, your process of discovery, and your attachment to a miserable piece of paper," I said. "Which is your priority?"

In a few seconds she would make the choice, either to open herself to exploration or to listen to her old habits, in which case she would justify herself by telling me I didn't understand her process.

"Listen," I said, "if you want to paint for product you know you can do it. With a little practice, anybody can paint a nice painting. You can do that anytime, so why not, for now, try a new direction and see how it touches you? You don't have to give up your old way of painting forever."

This made a little crack in her defenses, but I could sense her resistance. She desperately wanted to be an artist, and she was afraid that giving up concern for the product might destroy that dream.

"What would you do next," I asked, "if you had to keep going? You don't have to paint it; just tell me whatever comes up for you."

"Nothing," she said, suppressing a rising anger. "I can see nothing at all. It's all done—there's no room."

"You are not answering my question. What would you do if you *had* to?" This time I could sense an inner shift, a desire to try.

"I would put a turquoise line over there," she said.

"What else?" I asked quickly.

She couldn't believe I would dare ask for more. When it was such agony to find this one little line, there could not be anything else. She was getting upset under the pressure of being challenged again.

"Well, I could put some black birds in the right corner," she said spitefully. Then, after a pause, she remarked, "I think I like that. I might be interested in doing it."

"As you like," I said, leaving her alone.

An hour later Ingrid was still working on the same painting. She had painted a flock of birds and many details. She was radiant. She noticed me looking at her painting from a distance, came over, and said, "I understand now what you're talking about, but I really thought that nothing more could be done. I really thought it!"

The belief in her rational thinking had been broken, and the freedom of creativity had begun.

There is a tendency to think that you are finished when either you don't know what to do, or you don't like it and want to get rid of it, or you like it and are afraid to ruin it.

These are not valid reasons to stop. You are finished only when the painting is finished inside you. The painting decides, not you; the natural intuitive process decides, not you.

If you don't discover what it means to be finished, you will never be really fulfilled by your work. When you have done everything that seems possible, when you are certain that you are finished and you keep painting, you have to come from another place inside. That place is the seat of passion.

*If you believe you are finished, ask yourself what is not allowed
to be in your painting . . . and then see
if you want to paint it!*

welcome
to the earth

*I*n painting there is often a fear of doing something precise, definite, explicit—a fear of the particular image. This belief—that to commit to a specific form means a potential is lost, and that freedom is tied to the undefined— seems deeply rooted in human nature.

Tony did not seem to inhabit his body except for his two dark eyes. He had come to a seven-day workshop to explore himself, break old patterns, and take a vacation from his intense and responsible work of helping people. He painted abstractly, barely evoking or suggesting his feelings, never

committing himself to a direct expression. As I was explor-
ing with him the start of his next painting, he mentioned to
me that he would like to do a self-portrait.

To help him loosen up I gave him a small piece of paper
with a clipboard and a pen. "Could you draw the outline of
your body without ever lifting your pen from the paper?" I
asked. "Let yourself sense every curve and detail without
worrying about proportion, posture, or expression. Follow
the primary impulse of your hand without composing, while
keeping inside of you the idea of your body. The more pre-
cise you are, the better."

I did not want him to intellectualize, I wanted him to
feel. I did not want him to plan or organize the shapes, but
to move faster than his thoughts.

By not lifting his pen, Tony could not control the out-
come; it was too immediate for him to conceptualize in ad-
vance. This forced him to sense his creative energy and
respond directly to the feeling without the middleman of his
intellect. As he hesitantly explored a few outlines, unfamil-
iar feelings and sensations arose.

A few minutes later a complete outline of a blue
body appeared on his painting, filling almost the entire
space. "I'm all shaken up," he said as tears came to his
eyes.

"It's good to feel," he added after a moment.

"Welcome to the earth," I said.

———

To paint a personal image in our own way may seem too simple or primitive. So we reveal ourselves only partially, barely allowing a hint of form, suggesting just a minimum of definition. We are afraid that by allowing the particular to be painted it will imprison us. But the reverse is actually true: to be willing to be specific is to dive into our freedom.

The images that you have inside are authentic, and they need commitment and care in order for you to grow. When you paint personal images, their significance is found not just in the content but in what moves them, the energy that has brought the painting together, the life in it. When you let these images take form in their own unique way, you are in touch with something beyond yourself. The universal is not separate from the personal. On the contrary, the universal uses the personal to manifest.

Freedom is not tied to the undefined or the abstract. Very powerful feelings come up when you let yourself be more definite. Don't be afraid to paint what you think is childish, ridiculous, or sensual. Remember: You are not defined by what you paint; you are the creative channel through which it flows.

self-discovery

*Listen. Make a way for yourself
inside yourself. Stop looking
in the other way of looking.
You already have the precious mixture
that will make you well. Use it.*

—RUMI

*R*on was standing in front of his new painting, feeling very good about himself.

"I've just made a major discovery," he told me. "I was doing a painting of my body and I made one arm all black. Then I realized that my ability to reach out to the rest of the world is undeveloped because of my lack of will. It's something I've been working on. So I painted my other arm green, to symbolize new growth. The right side of my body is black and the left side is green because . . ."

My mind swirled as he went on describing his newfound meaning in the painting. Is this self-discovery? Is this the sort of information that creative painting is meant to give us about ourselves—to define new issues for us to work on, to make statements and conclusions that we can file away with other bits of self-knowledge?

Self-definition is not self-discovery. The purpose of spontaneous painting is to free us from the tightly woven shells of our self-knowledge, not to create more limiting labels, more definitions about ourselves. On the contrary, we already know too much about ourselves! To use the painting process to add more to that burden is to do ourselves a great disservice.

Self-discovery is about opening to the mystery—knowing less about yourself, not more. When you forget yourself and follow the movement of images, forms, and colors as they emerge, that is true discovery.

The experience of facing the unknown and allowing a world to arise from the void is the ultimate act of creation. And the self that is revealed in this movement is not defined or limited by the content of the painting. The painting is merely the vehicle that brings form to creation. The discovered self is that undefinable presence that is unveiled as you travel and encompass more and more of your inner experience. The paintings are just impressions, tracks left along

the riverbank. You have already moved on. To identify your-
self with the paintings rather than with the movement is to
deny who you really are.

I knew that Ron was not ready to hear these things; he
was too taken by his discoveries. I had no choice then but to
leave him alone, but I knew there would come a time in the
near future when he would be open to another direction of
inquiry. Concepts take you only so far if they are not sup-
ported by true feeling. The creative process is intelligent
and will eventually bring you to an abrupt halt when it is
time to put you back on the path of real self-discovery.

A few minutes later, Ron was taking his painting off the
wall. I came over to find him disenchanted.

"I'm not sure this is for me," he said. "I wanted to paint
the two sides of my nature, but they just didn't come out
right. Now I've got this great big gray blob and I don't know
what to do with it."

"Let's try this, Ron," I said, helping him put his paint-
ing back up. "I want you to keep painting, but forget about
making a statement about yourself. Just respond to the
spaces that call you, add colors or lines. Unrecognizable
things are all right, too."

With some hesitation he picked up a small brush and
began to make marks on his painting. He was obviously not
enthralled by the idea, but he was willing to try. After a few
minutes he said to me, "I feel really stupid. This is a waste
of time. I'm not accomplishing anything! Why am I doing
this?"

"This is the wrong time for questions," I answered. "Just keep going. This is an exercise in doing for nothing. It is one of the most advanced techniques," I joked. We laughed as I left him to do his meaningless marks.

We are at a loss when the mind cannot understand the reason for our actions. To continue under these circumstances requires a basic trust in yourself that transcends the content or the ascribed meaning of your actions. You are challenged to discover that the moment in itself is enough—and not merely enough, but absolutely complete—in fact, the moment is all there is.

I came back to check on Ron after another half hour or so. He was deeply involved in adding little squiggles to a patch of violet near the upper corner of his painting, and didn't even notice me watching him. His conscious mind was now submerged and would most likely resurface later, wondering where he had been.

Ron had been trying to get somewhere. He had an agenda that mapped out his starting point and his destination. Now he was off-road and really exploring. His encounter with being at a loss, with feeling stupid, as he put it, was actually the door to the real self-discovery he had been searching for. He knew less about himself and was therefore ready to encounter something new. His perceived lack of direction or meaning was really his greatest ally. With the thought of what he was doing no longer at the forefront of his

mind, there was room for other perceptions and feelings to arise. It would take a while for his conscious appreciation to catch up with his inner state, but he was now embarking on a voyage of true discovery.

If you find yourself too involved with the meaning of the painting, ask yourself: What would I do if I painted something that didn't have to make sense?

a little
life left

usanna had a wonderful smile—warm, innocent, enveloping. She had been diagnosed with terminal cancer. She arrived at the studio quite afraid to paint. "I don't know how to do it, I can't paint," she said.

On the second day she courageously attempted to paint herself. The upper part of her body she painted all black.

"That's the part of me that is already dead," she said sadly.

But the legs were pink.

"There's a little life left there," she added, pointing. "I

painted exactly what's happening to me. I'm finished now, and I'm tired," she said. She lowered her slightly heavy body onto one of our little stools, looking drained.

"Maybe we can make an experiment," I said. "Let's get up and take a brush and see what more can happen."

"No, no," she said. "I'm done."

I had not seen her smile for hours, but her smile was still in me. I knew of her capacity to give of herself and play. She had not yet touched the pure nonverbal gesture, the depth of her own spontaneity. She needed to break her belief about what was possible and her control over what she was doing. Her interpretation of the painting was stopping her.

I took her by the hand toward the paints. She chose a big brush, and with it a deep dark green. I asked her to use it without taking time to think. "I don't know what to do," she said.

I laughed as she put the brush on the paper, painting a space that had already been done.

"What about doing something new?" I said. "There is no point in doing anything else."

She shyly drew a line around the fingers in the painting.

"Good," I said. "If you don't know what to do, do something very small." I kept her painting as she moaned and complained half-seriously. I made sure she did not stop even for a moment, so her mind would not have time to regain control.

"I can't believe you made me do that," she said after a while. There was no frustration in her voice. Now I could leave her on her own. Later, when I came back, she was putting spots of bright color over the entire space.

"I guess there's still some life left in me," she said, astonished and happy. "Oh, I am enjoying myself."

She kept working on the same painting for a few more hours, adding colors in more and more intricate ways. A god figure appeared on top. The painting became rich, dense, and full.

Susanna was courageous. She listened to my suggestions with a child's curiosity, and kept going despite the temporary discomfort. By moving beyond meaning and interpretation, she discovered a new level of expression. She was only putting paint on paper, making lines and dots and little patches of color, nothing the mind could analyze or explain. Yet her brush knew precisely where to go and exactly which color to use. She had entered the simplicity of pure action.

The content of the painting is like a ripple on the surface of the ocean. The deep currents of the water, the constant tide, the rhythm that carries us while we paint, this is where the real meaning is. We are very fond of explanations and find illusory comfort there. We love to stir up memories and to make statements because they give us a false sense of identity. Every statement is a new fence we build around

ourselves that excludes other parts of us. Explanations are
an escape from feeling; assertions distract us from being in
the midst of our present experience, from moving step by
step on new ground. The drama that's on the painting truly
does not matter. What matters is what we are underneath it,
and this can only be experienced, not explained.

resistance

iane was late for class. This surprised me; she had always been on time, and seemed eager to come to the studio. The group had been painting for more than an hour when she walked in the door.

"I told myself I had phone calls to make this morning," she said. "Then my husband asked me why I wasn't going to painting class, and I realized I was resisting. I don't understand it. I've always looked forward to painting, but now I'm beginning to doubt myself. Maybe painting is not for me. I really don't think I should be here."

Diane was a therapist, accustomed to working with people through the various issues of resistance. Yet something was happening inside her that did not allow an objective perspective. She felt disturbed and she mistranslated it as an aversion to painting.

"What would you tell one of your clients in this situation?" I asked as we put her painting up on the wall. She looked at me with a sly smile and said, "Tricky."

When Diane looked at her unfinished painting of a large woman six feet high—surrounded by vines and as yet without a face—tears came to her eyes and flooded her with feeling. Within a few minutes her body shook with deep sobs.

"I don't understand why I feel so sad. I just want to paint tons of black tears pouring from her face," she said.

As myriad black tears poured from her brush, her own crying quieted down. She had found a way to focus and express herself. A few minutes later she added another piece of paper and painted black pools of tears down below, then yellow tentaclelike strands coming up and wrapping around the woman's body. I could see by the look on her face that her state had dramatically changed.

"I love painting this," she said, "I feel such relief, and I don't know why. I'm so used to working with people in a verbal mode to achieve this. It's amazing to discover that art can be such a powerful tool without ever having to use words. Now I don't want to stop painting!"

An important time to paint is when you resist it the most. The strength of the aversion means that there is something just beneath the surface, thinly disguised, ready to emerge. Resistance is a reminder to probe your inner fears and defenses.

If you find yourself experiencing resistance, ask: What would I least want to paint right now?

to create
is to be
a little
lost

There is a moment in every painting when we don't know where to go or what to do next. These times are very important, because they tell us something is being born. When we don't know what to paint, we generally think that there is something wrong, and sometimes we panic. But it is by facing the emptiness that creation arises. To be creative is to become more familiar with the sense of being a little lost. If we are always full of what we want to do, there is no room for the new.

It is good to keep painting during these times, to dig

further into yourself until you discover that after every hard moment there is an opening where unexpected feelings begin to stir. By facing difficulties, you reveal yourself to yourself, and the mystery unfolds. After all, you cannot know what you are going to express. What is really creative is bound to be a surprise because it's something you couldn't have thought of. When you start tasting discovery after these hard moments, it is like nothing else; it brings everything to life.

Tina was calling me anxiously. She had just painted a sandy beach. "I'm stuck," she said. "I really don't know what to do. I've been standing here for ten minutes trying to think of something."

I put my arm around her shoulders and said, "Let's go to the table and take a brush." We walked a couple of steps together. Her hand was tight, hesitant; she couldn't decide upon a brush.

"Take any one," I said. She looked at me skeptically. "Any one," I repeated, "but don't hesitate."

"But, but . . ." Her doubting hand reached toward the green.

"Put it on the paper," I said slowly. "Remember, you have nothing to lose. The brush will know what to do."

She came close to starting but withdrew again. The thought of making a mistake frightened her.

"Even a dot, or a little line, or a small shape, but don't

wait." Finally, reluctantly, she put a green dot on the beach she had painted. All at once, an exotic-looking plant was growing.

The plant was waiting to be painted, but Tina did not consciously know this. By surrendering to the simple act of picking up a brush, she was able to get out of the way and allow the image to arise from the void.

the
brick wall:
creative blocks

*To make what fate intends for me
my own intention.*

—CARL JUNG

I want to make clear that I don't believe in creative blocks, because after teaching for many years and painting thousands of paintings, I have never encountered one. Since it is taken for granted that they do exist, let's talk about this most famous ghost.

A block is experienced as feeling blank, with no idea of what to do. Even the smallest stroke feels dry and empty, and no desire is left except to quit. What worked before doesn't satisfy you. You feel discouraged or frustrated or you

simply don't care about anything. It has been described to me as running into a brick wall.

What we call blocks are transition times. Sometimes they are intimidating, but when you come down to it, a block is simply a time of change. Something drastically different from what has been painted is trying to emerge, and you are pushing it back down, consciously or unconsciously. You feel blank because there is too much inside and the pressure gives the illusion of emptiness.

This is a time to break the boundaries set by the self-image, to find the crack in the wall. One way is to have your brush do the work for you. Take a color without choosing it. Then let the brush paint what *it* wants, not what you want— a dot, a line, a blob, anything. It can be very big or small, but it must be done immediately, before you can think.

This approach has an uncanny way of short-circuiting the controller, for it is painting without reason, and usually within a few minutes the connection with the creative flow is reestablished.

You can also experiment with changing brush size:

- if you were using a big brush, change to a small one;
- if you were using a small brush, change to a big one.

Don't stop yourself by thinking that the painting is already full, almost finished. You are in an emergency situation and much can still happen. New elements do not need

to be consistent; there is *always* enough room for what you
need to do. Taking a new sheet of paper will defeat your
attempt. Instead, ask yourself what you would do if

- you were not afraid to change or ruin your paint-
 ing;
- anything could come into your painting from any
 side;
- you were going to paint something drastic;
- you let yourself dare, experiment, take a big risk;
- something large (or part of something large) were
 to enter your painting.

If you do not get much response, ask a more startling
question, such as what you would do if

- you lost control for a moment;
- you painted the wrong thing;
- you painted something that might disturb you.

You can use imaginary people to fool yourself into feel-
ing again. For instance, if a crazy lady came through the
door right now and painted on your painting, what would she
do? I have used the services of the crazy lady for years. She
has done wonders in our workshops.

Once I asked a student for whom nothing seemed to
work, what her sister would paint. She had no sister, but that
did it. For days I would ask what her sister would do, and an
answer would come instantly, while she herself was totally
blank.

Of course, all questions have to be carried to the end and answered in detail to be effective. I do this until the student feels interested again and eager, until a spark shines in the eyes.

Boredom, frustration, and tiredness are not indications to stop; they are signs that you are not doing what you really want to do. It is important not to give up, but to respond to the challenge of the brick wall. If you quit, you will not learn about so-called blocks, and you might be discouraged from painting again. When you face the wall creatively you realize you do not have to feel helpless in painting, because there are always possibilities. You develop faith in yourself and see that your creative ability need never be doubted or stopped. You acquire a taste for suspense and become intrigued by the unexpected move that is looking for you. It might attract you or repel you, it might be fearsome or exhilarating, but it will wake you up.

a horse
is a horse
is a horse

There is often the temptation to change an intended image into something else. Let's say you are painting a horse; as you begin to shape the body, it looks too long. You decide to make it into a whale instead; after all, that back hoof even looks like a fin. But the whale looks too fat now, as if you crossed it with a horse. A cigar would be more like it, yes, you will turn the whale into a thick brown cigar. . . .

Do you see the danger in changing the content of the painting to fit each momentary reaction? As your original

intention is lost, so too is your enthusiasm to proceed. You have nothing solid to respond to, everything is changing, you are working in a fog. You are thrown around by the whims of your critic. As soon as you don't like something, you abandon it. Very quickly you feel discouraged, convinced of your inability to paint.

It takes integrity to stand firm by your original intention. This does not mean having your whole painting planned out ahead of time. You just know your primary direction: you are starting with a horse. You don't know what sort of strange or unusual horse it may turn out to be, but it is a horse. A horse is a horse is a horse; it doesn't become something else. You don't know what may appear around the horse, or on the horse, or how many other horses may appear, so it doesn't have to limit your freedom. There is still plenty of room to explore.

There are moments in each painting when it doesn't turn out as you wished. This is good! This is a time to let go, to let the image find its own way onto the paper, to discover that there is a life to the painting that is not just part of your own agenda. But if you throw in the towel by aborting the process, distrusting the image's ability to reveal itself, then the painting loses its power to draw you out.

You grow through responding to what is. Honoring what takes form on the paper is a great discipline. You are put in a corner where you have no choice but to respond creatively. Your judgments must drop away one by one. Your concepts of the anticipated outcome have to loosen. You are chal-

lenged to become inwardly flexible, allowing all sorts of un-expected feelings to arise and take their places. By respecting what comes out of you, whether you momentarily approve of it or not, you are building a trust in yourself that will carry you through any creative block.

to care
and
not to care

Lynette had been painting for nearly four days in an intensive workshop. She repeatedly arrived at a place in her process where she felt frustrated and discouraged, not caring at all for the painting. From that point on, although continuing to work, she would add things for which she had no feeling, applying paint in a careless and sloppy manner, as if defeated by circumstance. All the joy was taken out of her creation, and she looked distracted and distant as she stood in front of her painting.

"Lynette," I said, "right now you are telling yourself that the painting is a worthless mistake, so you are treating it—as well as yourself—without respect. Try this: Act as if you cared about your painting. Put the brush on the paper with intention, not covering or going over what is already painted. Paint with care for a few minutes, then see how you feel."

Freedom does not equate with carelessness. Being careless can actually be a symptom of caring too much: your attachment to the outcome causes you to react negatively. Without care there is no relationship, no connection between you and your painting. The thread of feeling that links you to your creation is the most precious thing of all; it is the conduit through which your energy passes. If that feeling is one of hopelessness and defeat, the inner connection breaks and the integrity of the moment is lost.

At the other extreme, painting with care does not mean being overly careful, attached to results, trying to make things perfect. The real care is in the doing, in the intention at the actual moment of painting, not in the outcome. I often tell my students, "Don't worry about the result. It's none of your business!"

When you finally realize that you don't have to stand guard over what you create, you can afford to experiment, move on, play with what life gives you. You can

let the images come. They may be bold, with broad, quick strokes, or with fine, intricate lines and images. They shock you . . . it doesn't matter. You like them . . . it doesn't matter. They disturb you . . . it doesn't matter. You make friends with the brushes and let them paint. They know what to do!

break
the rules!

No guru, no method, no teacher.

—Van Morrison

Kerry appeared perplexed as I walked up to her. "I've always respected your advice," she said, "but I'm thoroughly confused. You suggested that I paint with care, and it helped me get through a period of judging my work. But now you're telling me to loosen up and paint more quickly. Which way is it? You seem to be contradicting yourself."

———

One of the most challenging aspects of the spontaneous painting process is the danger of making rules to follow. Each response that fulfills a particular need at a particular time must inevitably be contradicted by another response at another time. There is no recipe in creative expression. The admonition to begin very slowly and not fill up the void too quickly must be abandoned when there is a need to move with large brushstrokes and bold images. The advice not to stare at your painting must be tempered by the occasional need to stop and sense the next step. What worked before when confronting a creative block will be only a dead technique next time.

If we are honest, we will admit that we would prefer to have a set of rules to guide us on the difficult journey into the unknown. Rules seem infinitely preferable to standing naked before the white void, feeling like a beginner again and not being able to rely on one's experience in creating. You will, in fact, devise all sorts of rules, both from what you have been told by others—including us—and from your own experiences, and these rules will later have to be broken for you to proceed.

All rules are based on what has worked before, or on what we think it means to do it right. Rules take us away from ourselves, from our true feelings, because we are then striving to achieve rather than to create. Creating is a gesture without precedent, and no rules apply.

*When you encounter a block, look inside for a rule to break!
Remember: It's not the painting that's important, it's you. Once the
painting is finished, it's just a piece of paper with paint on it—
and there will be hundreds more!*

follow
your brush,
but don't
follow
your brush

Marilee, a bright-eyed young woman, announced the first night while introducing herself that she was at a pre-kindergarten stage of painting. With extensive experience in intuitive movement, she was determined to find spontaneity and freedom in her visual work. During the initial meeting of the workshop I suggested letting go of the product by letting the brush paint. Marilee loved the idea of following the brush—and she grabbed it.

For more than a day Marilee worked hard at applying her newfound method. She would generate some kind of

movement in her body and follow it, touching the paper here
and there, thinking she was free. Yet only a small part of her
was responding to the painting, not enough to carry the
depth of her inner need, the uniqueness of her real intuition.
She was a prisoner of her newfound technique. I watched
her enthusiasm and energy steadily decrease until finally
she admitted it didn't work.

"I've been following my brush, just like you said, but I
am getting tired and bored. I don't know what else to do,"
she said, quite disappointed.

"Well," I said, "why don't you try *not* following your
brush?"

Her eyes opened wide at this unexpected suggestion.
She was mute for a moment, probing me. Then I saw some-
thing shift inside her.

"Okay," she said, "I'll do it."

She turned to her painting, not knowing what was next,
and hesitated. As she listened inside, a feeling led her to
put a new green color on the brush, and she painted a
curved line inside a mysterious shape. The quality of her
gesture had already changed; her whole body was in it. Her
attachment to her imagined technique of following the brush
had cut her off from her feelings. But now she was respond-
ing from inside, sensing the color and the shape from mo-
ment to moment, being vulnerable, open to possibilities.

Within minutes her painting took on a new life: images
appeared, details grew. Her body moved with presence.
Freed from the constraint of a homemade rule, she was now

tasting true creation. Her failure at using the crutch of technique opened a new door in her, and she discovered that she did not need to know how to do it anymore.

We are eager for "ways to do it." When not given any, we make them up from what we hear. All rules are clever ways of staying in control, of avoiding real issues, of not responding fully.

To be without guidelines can be very scary, because the trust in our creative power is so weak. The role of a teacher is to dismantle the rules and techniques that students keep erecting in their hesitant approach, and to return the students to the infinite potential of their own being.

tricks
and crutches

The great majority of artists are throwing
themselves in with life-preservers around their necks,
and more often than not it is the life-preserver
which sinks them.

—HENRY MILLER

ulie was holding her brush in a very awkward way,
trying to paint a big black cat with her left hand.

"Julie," I asked, "is that the hand you usually
use?"

"No," she said, "I wanted to experiment with my other
hand. I thought it could help me unblock my creativity."

Astrid was turning her painting upside down. "I like it
better this way, it inspires me to go on," she said.

Allen was using two brushes at once, one in each hand.

To create you need to free your power from inside, not

outside. If you depend on a trick or a crutch, you won't develop the inner strength that it takes to create, you won't learn to rely solely upon your own resources. Tricks will stimulate only part of you, depriving you of the opportunity for a total response. Your creative muscle won't develop because it will not be used fully.

To create is to work on the level of the soul. Changing hands or turning the paper around won't touch it. There might be a little spurt of newness, but the waters will soon dry up again. Even if a trick was working for a while, you would then depend on it and lose your freedom.

It is true that different techniques will bring about different results. Manipulating your environment or using materials in an unorthodox way may influence the work, but it will be just that—influenced. What is of most interest creatively is that which is uninfluenced, that which comes directly from inside when you do things in your natural way.

There is great beauty in the simple use of basic tools without the distraction of novel approaches. Then, when a need for a new direction or deeper contact arises, there are no sanctioned avenues of escape, either by altering your way of working or choosing a different medium. Then you don't rely on tricks or crutches—you carry your creativity inside you.

repetition, compulsion, and indulgence

"I've painted these little floating heads in the background for the third time now. I feel weird repeating the same image over and over. I don't know why I'm doing it. Maybe I'm being compulsive," said Dorothy, in a disappointed voice. She had spent the last few days enjoying her mysterious images. Now she was judging them.

"Are you telling me that there is something wrong with painting an image more than once?" I asked.

"Yes," she answered. "It seems I can't think of anything else. I'm afraid I'm just being decorative and indulgent. My

imagination must be very limited. I wish I could paint some-
thing new!"

"Don't repeat, don't copy!" We have heard that statement
over and over. We assume that to repeat a subject is proof of
our dullness and our lack of inventiveness.

On the contrary, it often shows sensitivity. When you
paint an image or a color that has great feeling, it is not only
natural but perhaps essential to repeat it. The more powerful
the image, the deeper its root, and the greater the likelihood
you will have to repaint it. As you do repaint it, you are
exploring different aspects of the feeling, with all their sub-
tleties, from every possible angle. The image will come back
as long as it is needed to fulfill its role. Creation works in
cycles: each powerful urge is a wave that rises slowly and
needs to reach its peak before ebbing away. The expression
of that particular aspect of you will have to complete itself
no matter how many repaintings it takes, no matter what you
think about it. Only then will you move on.

We are usually not aware of the deeper levels of learn-
ing and healing we are going through. Insights arise sponta-
neously from this kind of work hours, days, or even weeks
afterward. Repetition does not come from a weakness of
imagination or from compulsion; it comes from an attitude of
openness and freedom, and a willingness to surrender to the
natural wisdom of the creative process. Your images are only

demanding to finish their life spans. Do not cut their lives short—they have something to give you.

If you find yourself worrying about something you want to paint, think about this: What would you do if you went too far?

feeling
vs.
emotion

Feelings, like creativity, are natural: they are our response to life meeting us. When feelings are buried by prejudices or concepts, they grow restless until they are heard and given room to express themselves. Through them, life struggles to break free and flow. In painting, intense feelings are never a problem if we do not try to manipulate or avoid them.

Emotion is the echo of feelings as they reach the thinking process, where they get labeled, categorized, isolated.

Emotion is conscious of itself and brings associations from the past and projects into the future. It can bring reactions that may be intense, but emotion is basically feeling with the head.

Sally looked tense in front of her painting. I approached her and asked how she was doing.

"I am feeling angry. It came over me without warning. One moment I was painting happily, and the next moment I was upset." Shortly before that Sally had been in love with her work, almost ecstatic, believing she could paint forever.

How can we trust these ever-changing moods? They come with such certainty one moment, then change radically without any apparent reason. Once you begin to open yourself to follow the inner movement of your feeling, you are bound to encounter resistance from your emotions. Emotions are often tied to judgments; their purpose is to avoid real feeling.

"Sally," I said, "can you tell me the sequence of inner states that preceded this anger at your painting?"

"I was painting a figure for the first time," she answered. "I felt unsettled with the way it was turning out, and I started looking around at other people's paintings, comparing mine to theirs. I remembered a grade-school teacher who criticized me for not being able to draw. My painting seemed

ridiculous and I wanted to rip it off the wall and hide it. I began to feel like a failure. Now I can't do anything. I'm blocked."

Sally's emotions had been successful at masking her primary feeling by distracting her with high drama. The beginning—the disquieting feeling of having created something new and not knowing how to respond to it—was the critical moment. This was feeling. It was without definition or label. It had no comparison, judgment, or conclusion. It was an unqualified response to the new. The rest was the downhill slide into the familiar world of conflict and confusion. The painting process asks us to remain in the world of feeling, which precedes the mind, with its past comparisons and future expectations.

Feeling is not definable, it cannot be known in the usual way. If you label your feeling, then you are tempted to resolve it with your intellect. Feeling is an experience and therefore can be addressed only on the level of experience. To attempt to know your feeling while painting is to lose touch with it.

If you find yourself overwhelmed by your emotions, make your brush move faster than your thoughts. It will help you disengage from the drama.

monsters
unleashed!

If you don't break your ropes
while you are alive,
do you think
ghosts will do it after?

—KABIR

Corinne had lots of intense energy, but her beautiful features betrayed a deep, ongoing sadness. Her life had never been easy. She held on to art as a savior; creation pulled her out of her depressed mood and, as she put it, kept her alive.

As we explored what she might paint, she discovered a very old and heavy pain.

"It's like a dark wall," she said, "and when I feel this wall I just want to cry and cry. . . ."

"What other images do you sense around that wall?" I
asked.

"A big, frightening monster," she said, startled by her
admission.

"Why not paint it directly, as you feel it now? Move
right into it and let the images unfold. The only way out is
through."

"I'm afraid it will make something terrible happen," she
responded.

It took a lot of courage for Corinne to paint that threat-
ening presence. I stayed nearby to support her and refocus
her attention when she tried to obliterate the image or
change it into something else. As she remained with the
feeling, her expression strengthened and she finally touched
the core of her pain. I stayed beside her and put my arm
around her shoulders. After what seemed like a long time,
her sobbing receded, and she became quietly absorbed in
painting tiny blue and yellow details. Corinne, by not avoid-
ing or denying her feelings, had passed through the content
of her painting as if through a tunnel, and now she was
sailing on a calm sea. She had moved into the present, one
small stroke at a time.

The fear of confronting monsters can keep even sensitive
and willing people from diving into the creative sea. These
threatening shapes seem real, and it feels dangerous to un-
leash them. But they are part of the setting in which the

actor must play many parts—comic, dramatic, horrific, spiritual. Quite often, these demons guard the doors of our inner world and must be faced before we can enter the heart chamber of our mysterious existence. Their dark presences play a role that we do not always understand. Sometimes they embody our resistance to relinquishing control, or they may express old repressed hurts. Other times they may be protective, or an expression of our perception of darkness. It is best not to draw any conclusions about them but to let them grow and mature in the painting until their function is exhausted.

Sometimes people are concerned that painting threatening images will cause the events to happen in real life. This belief is like the superstition that talking about death will bring death. It is not the case: on the contrary, confronting and expressing these images can only be good, because by doing so our secret fears are released, our hidden shadows and beliefs revealed. Spontaneous creation always aims its beam at what we do not know about ourselves and illuminates it. When the darkness is exposed to the light, it disappears.

If you find yourself afraid to paint an image, ask yourself: What would I paint if there were no bad consequences and no punishment?

is it therapy?

*G*eorgia painted a large image of her abusive father. At first she worked with great abandon, then with tension and resistance.

"It makes me sad to paint this," she said. "It's so painful and ugly. I've been dealing with this for so many years in therapy. Will it help to work on it here, too?"

Creative painting is not about exposing problems and trying to resolve them. It is not about working with the content of

your life and deciding what needs to be changed. As the creative force passes through your inner world, it carries images and feelings that are uncompleted, unfinished, misunderstood, not experienced, or denied. By spontaneously painting them, healing happens, not because of what you do with the image or meaning, but because of the powerful cleansing energy of creativity. It is therapeutic in that sense.

The question when you paint is: When you open to the whole of who you are, what happens? The question is not: When you open to one part, what happens?

"But I feel I should resolve the problem with my father," Georgia said.

"As you paint without attributing meaning, you are contacting a greater intelligence. The channel of your intuition is opened and insights emerge that may not be directly related to the content of the painting, but they will be important to you and relevant to your life."

"But I feel that I've painted into that scene everything that happened. There's nothing left—I've done it all!"

"No," I said, "you painted all you knew about the scene. Now it is time to paint what you do not know."

"Okay, I'll try," she said, picking up a fine brush and putting a mark inside her father's heart.

"Again," I said. I stayed close to her for five minutes, repeating "Again" anytime she stopped.

Soon her brush understood that one little step at a time was enough to connect with the creative stream. She grew bolder and started to change colors often, as if she really

knew how to move into the unknown. The sadness about the meaning of her painting slowly dissolved, along with her fear and her anxious mind. The context of her feeling had expanded, and now she was seeing things from a greater perspective. There was no more need to resolve any particular problem.

The content of the painting may be related to precise past or present events or feelings. You might recognize them, experience them as you paint, and then let them go, moving on. Your being relearns to sense itself as whole rather than divided into compartments, each with its own need for resolution. Like a broom that sweeps away dust and residue, creation acts as a purification of what has accumulated in the life of the psyche. It is neither your role nor to your advantage to analyze the dust, but only to let the cleansing take place.

If you are attempting to resolve a problem with your painting, think about this: Does the creative process need you to check on its progress, or can it be trusted to do its work of healing?

erotic images

Forget safety.
Live where you fear to live.
Destroy your reputation.
Be notorious.

—RUMI

Rachelle had been painting with us for a few months. A shy woman in her mid-forties, she painted for her own pleasure. Today she had made a large image of a woman whom she said was herself, standing firmly in the center of the painting. She had told me she saw numerous black snakes coiled at the woman's feet, and had started to paint them. Now she called me over in something of a panic.

"I'm so embarrassed about this," she said. "But along with these snakes I see a lot of penises pointing toward the woman. If I were to do what I really wanted to, I'd paint

hundreds of them all over the place. But that would be so vulgar and crude. What would people think of me for painting that? I have the feeling someone will come up to me and tell me to stop, that I've gone too far."

Sexual images are an important vehicle for many of our feelings, and we should not take them at face value. Sexuality embodies breakthrough, intimate connection, surrender, abandonment, self-transcendence, and ultimately, death and rebirth. To label sexual imagery too strictly is to lose the essence of free expression.

When we begin to lift the veils of censorship and repression in painting, a great deal of energy is unleashed. This can sometimes manifest as strong sexual imagery. Sexuality is a powerful expression of human creativity, and it is inevitable that erotic themes will appear in a spontaneous painting process. Their force is made all the stronger because of the social taboo against expressing sexuality, and these images may appear and persist as inner freedom is developed.

"Sexual images are not just about sex, they are about energy," I told Rachelle. "Go for the energy. The images are only tools to express your passionate intensity. It is your own life energy that is at stake. Are you willing to trade the release and connection you feel when you are fully engaged with your creativity for an image that might be more proper, more acceptable, less provocative?"

Rachelle went back to her painting and quickly became oblivious to the room and everyone in it. An hour later she

had filled up her painting with the snake-penises. "I am ready to start a new painting right now," she said with enthusiasm, "and I know exactly what I want to do!" Rachelle went quickly to a new piece of paper and painted a couple in a wild embrace of lovemaking.

Energy can be expressed in many forms, but the shape it takes is of secondary importance. We have within us enormous reserves of trapped potential. Our natural urges have been so constrained by the accommodations of living that we each have a smoldering volcano just below the surface. To enable this force to erupt in a healthy, open, and positive manner is a momentous act.

What would you paint if you could afford to be shamelessly uninhibited about what you created?

painting
god

What is art? It is the response of man's creative soul to the call of the Real.

—RABINDRANATH TAGORE

Martha was daubing splotches of red at a furious pace all over the lower third of her painting. Her intensity caught my eye as I passed. She had always been such a careful and methodical painter, assessing each brushstroke and new image in her mind before it appeared. Now she was painting with an abandon I had never seen in her before.

As I approached, she stopped me and said, "I'm afraid I'm becoming too careless. I've never been so sloppy be-

fore, but this red has so much feeling for me! I keep get-
ting the strange sense that it's the blood of Christ. But
that's ridiculous—I stopped being a Catholic years ago!"

As the class progressed I could see that Martha was
encountering feelings that she couldn't comprehend. When
you set aside the mantle of control in the painting process,
images arise from ancient layers of the psyche that may not
fit with the conscious perceptions you have of yourself.
These images often have a strange immediacy and familiar-
ity that are difficult to understand in light of your per-
sonal history. You have within you images and perceptions
that carry universal themes far beyond your actual experi-
ence.

Martha was venturing into that place of mystery now. As
she finished her painting and stood in front of a new white
sheet of paper, I asked, "Martha, if you were not afraid of
what people were going to think of you, if you were not
afraid that what you painted would require you to change
your idea of yourself or anything about your life, what would
you paint?"

Martha was quiet for a very long moment. I could sense
that she had gone into an inner place where something was
forming itself, wanting to emerge. Her face flushed and her
eyes moistened as she said, "I see an image of Jesus with
his arms spread wide, and there is so much light emanating
from his heart, which is exposed and bathed in his own
blood. And he is so close—I see him right here!" She was

trembling, genuinely moved by the forceful presence of the image.

Then she quickly added: "What is this? What's going on here?"

It is difficult to accept the incongruity we feel in ourselves when we open to another dimension of vision and feeling that cannot be explained in terms of our memories. Its reality is unmistakable, yet it doesn't fit, and we are often frightened by the imagined ramifications. We are afraid that we will have to undergo a religious conversion or join a group if we let ourselves paint God. It is interesting to see that the mind resists the spiritual side as much as the dark side—perhaps even more so. When true spiritual feeling emerges—not a preference for the light or an imagined spirituality, but contact with profoundly touching inner forces that are beyond our control—it is an extraordinary experience.

Religious and spiritual images have a necessary place in the unfolding of the creative process, just as do demons and monsters. These images are alive in us, coexisting with our conscious life on a more profound level of the psyche. Their presence makes itself known at unexpected times, mysteriously connected to an inner process of expansion that we are often barely aware of. The more you immerse yourself in the unfathomable richness of the intuitive world, the more you understand that your job is to honor these

images as would a respectful steward and to let them serve their function: a mysterious healing and transforming and evolving, a background constantly working in your favor and with your highest interests in mind, leading you to experience who you are in an ever deeper, yet simpler way.

going
toward
the light

Mysteries are not to be solved:
the eye goes blind
when it only wants to see why.

—RUMI

Francesca was painting a dark ocean tossed by turbulent waves. On the stormy waters she put herself in a little boat. Her hand trembled as she began to paint black strands rising from the ocean bottom and wrapping themselves around the boat, finally grabbing her.

"These are the tentacles of a huge sea monster," she told me as the painting became nearly filled with long, threatening fingers.

Painting this bleak scene carried a lot of feeling for Francesca. The quality of her energy at that moment was the

proof of her need to create these forms, and she vibrated with excitement as she allowed the powerful images to unfold.

Later Francesca stopped working and was sitting glassy-eyed in front of the wall where her painting hung.

"I'm finished now," she said. "I'm done with this story and there's nothing more to tell."

There was now a bright yellow sun in the upper corner of her painting, its rays pointing down toward the little boat. She had also painted a fluorescent circle of blue and orange fish in the water surrounding the boat.

"The sun came in to balance the darkness of the ocean," she went on, "and the fish will protect me from the sea monster. That's how I'm resolving this."

"How do you feel right now?" I asked as I brought her to a standing position again.

"To tell you the truth, I'm really disappointed," she said. "I was so intensely involved for most of the painting, but all of a sudden the feeling disappeared. I can't think of anything more to paint."

Francesca had lost the thread of her feeling when she decided to balance the painting. There is nothing wrong in adding bright images to a dark painting, but it was the intention with which she did it that threw her off track. Her desire to resolve the story was an intrusion into the creative current that had carried her so strongly. Perhaps she was frightened about the meaning of the painting, afraid to follow the so-called dark images as far as they needed to go. The

fact that her creation had left her devoid of feeling and
without energy was a signal that she had interfered and tried
to control the outcome.

"Francesca," I said, "if you were not afraid to mess up
your painting or lose the meaning you have now, what would
you do with this disappointment?"

"I'd paint some big black sharks eating the smaller
fish," she said, "and one of the sharks would even take a
bite out of the boat. And the sun's rays—I'd put black dots
in them. That would make me feel much better!"

We live in duality. That is why we have been given the gift
of creation—to be reminded to embrace all aspects of exis-
tence. Misery comes from cutting life in two: "I want the
good part, the spiritual part—not the rest." You couldn't
have beauty if you didn't have the other side. The dark is
going to come to you until you accept and welcome it. The
belief that you have to paint beautiful scenes or ethereal
figures so you can feel more spiritual is not true. When you
embrace the dark side, it stops being dark through the act of
creation.

Who can decide the ultimate significance of the dark
sea and the long tentacles of a sea monster? For every inter-
pretation there is another possibility. Perhaps the black
strands are the fingers of the unconscious trying to pry Fran-
cesca from the limited perspective of her personal reality.
Perhaps the sharks are her own creative energies cutting

through the tangle of lies and veils she uses to protect herself from the transforming power of the unknown.

Theories can be made one way or another about the content of your painting. The real issue is whether you trust the integrity of the process itself. If there is energy in it, do you dare do it? And do you dare follow it as far as it wants to go without needing to prematurely resolve it? When you have the courage to do what you must without fear of ramifications, there is a resolution far deeper than any you could impose on the painting. There is an intelligence within you that is superior to any solution contrived by the mind. If you dare follow the inner call without reservation, you are putting your trust in a reality that can never be captured by ideas or concepts. This is the challenge of creative exploration!

The spirit of creation, if you let it, will move you out of your familiar world into a larger dimension. This is why it is so important not to follow a story when you paint, lest it tie you to the limitation of what you know.

levels
of completion

There is a light seed grain inside.
You fill it with yourself, or it dies.

—RUMI

E very painting has its cycles of birth, maturation, and death, and within every cycle a pulse beats. There are several levels of completion, and after each level you have a strong impression that you are finished. The intellect tells you that you are done when you simply do not want to go on, when you resist a change, or when you are afraid to challenge yourself further. But if you work through this transition and touch the next level, you will be amazed at how easy and joyful it is to be carried by a new wind.

Then, the same phenomenon happens again, and once

more you are convinced that you are finished. If you pursue the exploration by adding more, the most important time of the painting will reveal itself, unfold, and fulfill you. Your creative potential will grow and mature only when you seek the greatest depth, when you reach beyond your limitations. Then and only then will you become passionate in your work.

If you stop at the first level, you are dealing with only the surface, never touching the hidden layers, never meeting the beauty of not knowing what to do, never really facing the void. It is relatively easy to start a painting, to put a few marks, shapes, or images on a white surface. But the real process begins only after this is done, when you run out of ideas, when you finally don't know what to do, when the path is narrow, for there is less room on the painting and there are fewer apparent options. It is then that you have to dig deeper in yourself, to relinquish control, and to tune in to larger dimensions and energies. Then you become the receiver rather than the doer.

To pursue the exploration to the end is the price of passion. It takes commitment, love of discovery, desire to use your whole potential, and a fascination for the mystery of living.

Jean was waiting for me, impatient to start a new painting.

"I've done everything I can; I'm all dried up inside. There's nothing left to do on this one."

I took a quick look at her face, dived into her eyes. How full she was, longing to be free. She was bursting, and her painting was meticulous, proper, in chains.

"Would you like to try something?" I asked. She nodded. "Let us take one of the big brushes," I said. I went along to the table to give her courage and momentum. She chose a bright red and shyly dipped the brush into it.

"Let's put a lot more paint on it," I said.

"A lot? But there's no room on my painting!"

"Now let's use it," I insisted. A few moments later, bold red strokes of paint were born at the bottom of the paper. Then she picked a yellow, an orange, working fast. Jean painted a volcano erupting. She had managed to break the spell that imprisoned her; she was now painting beyond anything she could have imagined, reaching further into herself, going to the end of the possible.

The painting and the person are one; they bloom together. When people are in touch with themselves, their physical postures change, creative energy emanates, life runs through their bodies. They become full of color instead of black and white.

Creative painting is a process of pioneering inner lands and perceptions. When this has not happened, the painting is incomplete and its purpose is unfulfilled, however crowded it may look. It needs the fresh water of honesty, the depth of simplicity.

The painting needs the fragrance of life. But life cannot be put there intentionally, either through technique or any kind of thinking. How many times I hear people say, "It needs life; I want to find something that will make the painting alive. It looks dead." This cannot work, for it is a mental, manipulative process, it aims at a known result.

Life is born of itself. It does not need your help. You are the womb for the creation of the painting, but the seed is not yours, nor its growth. You are the bearer only. When you do everything you can, honestly, without forcing anything, without impeding anything, then the process of creation is fulfilled.

You are finished when the painting is finished inside you. Try to keep going after you are absolutely certain you are finished. What comes then may be the most important time in your painting.

a good comment is a bad comment

Pat called me over. She was feeling empty and uninterested. As we explored possibilities, she had an idea.

"I could paint lava coming out of the mountain in the left-hand corner," she said with enthusiasm. "But I don't know at all how to paint lava."

"I am sure you can find a way to invent it," I said. "There are many kinds of lava in the world. Make it your own special lava."

Her hand became hesitant and tight as she struggled to

be realistic. The idea of what lava should look like froze her freedom and her playfulness.

Later, as she searched for the next step, she said excitedly, "More lava could come out here and here and here, and there too." She pointed to all the possible places in the painting. The feeling was strong; I could feel the heat and force of the lava already running in her blood. This time she let her brush paint, and was happily surprised.

"I can't believe that I am painting lava that looks so much like lava, feels like lava, is hot like lava!" she said with absolute delight.

Another painter, hearing her comment, looked over and said, "Oh, really, you think that looks like lava?"

Oops, I thought, trouble ahead . . .

Minutes later someone else came over and said, "I wish I could paint like you."

In the afternoon Pat's energy decreased and annoyance set in. She had stopped enjoying her lava even though she painted more of it, and she was nervous. As we talked, she expressed how disturbing the comments had been. "I feel caught in a small space, with no room to explore. I feel judged and evaluated. Even though I know they meant well, their comments disturbed me."

"Any comment, good or bad, will hurt the process," I always warn my students as we start a workshop. It is a strong habit to break. If somebody tells you they love your painting, you

will be afraid to add anything to it, fearful of diminishing its beauty. And if on the next painting the person does not make a similar comment, you will wonder if you have regressed. And if anyone around you hears the comment, they will be sad that it was not said about their painting. Finally, you will find that you consciously or unconsciously repeat what has been praised and avoid what has been criticized, losing your freedom because you want so badly to be liked.

It is good at the beginning to paint as if no one is going to see your work. People may praise what is dead and reject what is alive, or make comments that inhibit or influence you. Protect the fragile seed of your artistic freedom until you become solid in your creation. After all, you may spend many hours writing in your journal, unconcerned about showing it to the world. Why can't you have the same freedom in painting?

If you look at somebody else's work, or have someone look at yours, silence and respect are the greatest gifts. Look upon paintings with eyes of mystery rather than judgment. Support the need to enter into the sacred space beyond evaluation.

*How many times when you are painting do you wonder what
others will think about what you are doing?
How does this influence you?*

the process is the teacher

The outer teacher is merely a milestone.
It is only your inner teacher
that will walk with you to the goal,
for he is the goal.

—Sri Nisargadatta Maharaj

During a break in a workshop, Sarah came up to me. She seemed worried and intense. "I need to talk to you," she said, in a voice that would not accept any postponement.

"I want you to know that it's very hard for me to listen to your ideas. It's like being back in school, and I hate it. All my life I've been told what to do by my mother, my brother, my husband. I've never had any space for myself. I need to learn to trust myself, to listen to myself, not to oth-

ers. That's why I took this workshop." She was frustrated
and somewhat aggressive as she spoke.

"When you listen to me," I replied, "you do not have to
look at me as an authority. If you did, it would be another
way for you not to fully participate in your work. You would
be giving away what life has given you—the power to know
intuitively what you need. I am just a cleaning lady giving
you a hand with the housework. Or, if you prefer, I am a
chimney sweep, helping you clean out the soot so you can
build a big warming fire of your own. When I ask you to
trust, I ask you to trust the movement that unfolds through
you. I ask you to listen to what is really yours, not to what
you think I want or what pleases you. Listen inside. Ques-
tion what it means to be on your own. I want what you want:
for you to go beyond your conditioning and break the preju-
dices and fears that prevent your creative work."

The real teacher, the only teacher, is the creative process. It
guides, it reveals, it explores; it has in mind only to give you
what you need the most. The voice of the process that arises
from inside you has great wisdom. When you listen carefully
it always points to the next step. If the movement of your
process depended on one teacher, it would be limited and
subject to interpretation and misunderstanding. Worst of all,
it would create dependency.

Creation does not rely upon any form, any group, any
teacher, any philosophy. It is born of your own experience, it

is the wisdom of your own soul, and it will not suffer to be under outside influence or authority. This is why it is such a responsibility to be a so-called teacher or so-called student.

Creation aims at the experience of truth, a truth that has not been filtered by anything or anyone else. Most of the pain and misery of life come when we surrender the intelligence of our spontaneous intuition to other people or outside ideas, weakening our inner strength and understanding. The process of painting is about reclaiming both.

Teachers may be able to help you get started and, perhaps later on, they can provide support by pointing out blind spots and patterns. But remember: you are doing the work. Keep it as your own. It is the wise urge of creation that makes you grow, expand, and enter yourself. The middleman is not important. Do not give away to another the beauty of your own process.

dark
or
light?

*C*arol was absorbed in painting black birds eating parts of her broken body. These somber creatures surrounded her on all sides, practically filling the painting. It was not a happy activity, painting herself disappearing into the stomachs of these beasts, being engulfed in a darkness that they seemed to symbolize.

"It's okay," she said, "it feels right." But her face betrayed the presence of anxiety and the desire to have it over with.

Carol worked all day, nostalgic for a more soothing

painting. She still managed to care for every detail: the long, curved beaks; the crimson eyes; the tar black feathers; the fine red cracking of her own skin.

The next day, to her surprise, a gold heart suddenly appeared on the breast of each bird, radiating a beautiful light. Carol was profoundly moved by the love she felt for them.

"I can't believe how I feel," she said. "I'm so touched! The birds feel so different today . . . they carry a radiant quality I would never have suspected!"

By painting to the end of that darkness without mental manipulation, Carol had tapped into energies and meanings that reached far beyond what she could have imagined. She had moved to a place where it was not possible to label an image dark or light, because dark and light had exchanged clothes. In Carol's birds, light had donned a dark costume.

Appearances are deceptive; the mind interprets images using only what it already knows or believes. It pretends to discover what it is afraid of, or what it desires. Most of us resist the experience of true light as much as true darkness, because when true light arises in us it means change. Light burns away the false, and releases our grip on patterns and projections. In this sense, light is a destroyer, and our self-image fears it.

What was the purpose of the birds' feast? There is no need to probe this question. Opposites give us life. Their interplay has a harmony, as day and night need to embrace

each other. It is best to let the intelligence of creation do its work without interfering, to let it bring hidden levels to consciousness in its own time and way. Premature statements will impede deep work and prevent transcendence by excluding the intangible dimension brought by the creative process itself.

you
are not
your painting!

The creative force is like a beam of light: one moment it may focus on a flower or a god, the next moment on the underworld or the mud. With its rays of light it explores the whole universe, inner and outer, teaching consciousness to go beyond what it expects. Nothing is too ugly or too sacred for it.

You are not defined by what is revealed by the beam. You do not need to stop and take snapshots as if these images were dramatically important statements about who you

are. Could who you are be but a series of positive and nega-
tive statements? The craving to know about yourself is stim-
ulated more by a lack of being than a lack of knowing. To
think that a piece of paper with colors can define you is an
affront to life itself.

We always tend to identify with the last impression, the
last costume, the last painting that appears, good or bad.
Why cry on the dark ones and swell with pride on the
good-looking ones? Identification encloses us in a self-
image. When the self-image of a painter is present, painting
then becomes an in-house activity. Nothing new passes the
tight border of self-labels. Who are we without the costume?
Are we what paints or what is painted? This misunderstand-
ing is the origin of all creative blocks.

If we are what paints, let's stop wasting energy and time
on the product. Life is movement: it won't be found in any-
thing static. Whatever we think about the painting will only
increase our partial knowledge, which is already overex-
tended. Adding new bits to it won't help. We need a differ-
ent kind of knowing, one that develops through nonverbal
creation. Why not let the painting play its comedy and its
drama while we enjoy the show? If the process wants to
point out aspects of our personality, it will do so through
insight, not through deduction or analysis. The creative pro-
cess wants us to come back to who we really are, beyond the
images, the photos, the costumes.

Ultimately you can paint only what you are not. The pot

is not the water it contains. The river is not what it carries. Why identify with the driftwood that the river washes onto its shores? Who you really are lives beyond any definition or frame. It is uncapturable except for its spirit, which appears in the life of an honest stroke of paint, whatever its content.

creativity
and the
spirit

I do not know whose scheme this is
in the eternal cycle of beginning and end
that between feeling and form there should be this interchange,
that the bound should be on a search after freedom—
freedom asking to be housed in the bound.

—RABINDRANATH TAGORE

To create is to touch the spirit. It is found in the creative moment when you abandon yourself to the call of your intuition. It is there between the thoughts and demands of the conscious mind, in the mystery of the unknown as it manifests through form and color.

Art as process is a meditative activity. True painting is prayer; it happens when everything inside and outside joins in one action. Colors flow of their own accord, forms are born of the brush, content reveals itself from deep within. It is art in its essence—effortless, natural, obvious, inevitable.

What moves creation? Certainly not your little person. When you paint, you discover who is really there under the polished surface of your beliefs. Your energy is connected to a greater energy. You step out of your hiding place into a larger reality, because you open yourself to the unknown experience. You connect with the background of life, and at moments your boundaries dissolve. You become one with the movement of all things.

Then, no matter what is being painted of human dramas and joys, all is harmony, because the action that includes all actions is at play. Duality, with its opposites, moves without fear. When you paint, you embrace the spirit and move with the current of God's river, from form to the formless, to form again and again.

art
process as
spiritual practice

What I most want
is to spring out of this personality,
then to sit apart from that leaping.
I've lived too long where I can be reached.

—RUMI

The purpose of the creative process is never to satisfy the cravings of the personality, but to go beyond it. It is a practice of unlearning, of unburdening, of shedding beliefs and conditioning. True creative energy arises when the impersonal and the personal meet. To let that magic happen, the personality, with its heavy luggage, has to get out of the way. To paint for process is to enter the mystery of the spirit by practicing the basic principles of being and awakening.

Practice of keeping life fluid

You paint as you live. True creation faces you with your tendency to stop the movement of life by thinking, holding, and clinging to what you do. It keeps you inwardly on the move through its demands to go anywhere, anytime, no matter how unfamiliar. To truly create is to enter the fluidity of time and energy.

Practice of not knowing

To paint is to pass through the doorway from the known to the unknown. Let yourself be lost, wander in new lands, dare to be your unusual self. Painting is a killer of concepts, projections, and prejudices. It will break the masks of learned behavior and reveal the inexplicable.

Practice of direct action

You paint with a brush, not with your thoughts. By not manipulating, preparing, or adjusting what comes, you will free your painting from the constraints of the mind. A simple response from your whole being to color and form is all you need.

Practice of beauty as truth

Beauty is in the honest gesture. It is harmony between you and your work. Integrity and presence are its main ingredients. No aesthetic concepts can replace what is authentic. When you let go of result you are free to be yourself. There is no greater beauty than the manifestation of that truth.

Practice of no preference

Let anything appear on the painting—whether it be strange, awkward, sexual, dark, chaotic, beautiful, inspiring. Then all extremes are free to come and go unfettered, carrying with them the full range of feeling and thought.

Practice of no judgment

There is no need to judge a bud before it has a chance to bloom, or wish that its petals match your fleeting mood or the couch in your living room. What is born honestly deserves and needs the space of no judgment. The real painting takes place in your heart.

Practice of not working for results

What is worth more, your painting or your life? The time you have now is all you've got. Paint for the sake of the doing; inhabit your action. If you use the result for self-gratification or business, it will make you a prisoner of your desires. The outcome is only a by-product of a powerful process, ashes after the creative fire has burned.

Practice of non-attachment

Whatever place you have reached, you must let it go to keep your creation flowing. Any pride or disappointment in your painting will chain you to a spot from which you will compare and evaluate each future stroke. If you stop asking for what you do not need, what you need will come to you.

Practice of acceptance

Don't ask yourself for perfect behavior, including being a perfect painter for process! However much you think you have made a mistake or manipulated what you do, remember that each experience is part of the journey toward yourself. To truly create is to love yourself enough to encompass any feeling or thought that arises as you paint, no matter what color, shape, or image it is.

Practice of no self-image

Creation, if you let it, will force you out of the limited definition of who you think you are. Painting practice is not a self-centered activity but a self-exploding activity.

Art process is a living thing; it breathes and its heartbeat is in your soul. Done for its own sake, it is an act of love, part of the movement of the universe, merging with it. It is a gift to life, a prayer, a song that disappears in the wind. Why gather to yourself when you are already so heavy with inner and outer possessions? Why invest in something impermanent, something that in an instant will become the past? Spontaneous process touches what lasts, which is out of time.

if
painting
were just
about
painting . . .

If painting were just about painting, it would be of little interest. Painting does not inhabit a limited compartment of life, but thrusts its roots and branches into the deepest parts of us, transforming our ways of being.

Painting is just one tool for creative exploration. The tool you choose is not important, whether it be writing, acting, dancing, speaking, or making music. It is how you do it that counts. Do you have the right understanding of creation? Have you fully met the creative spirit? Did you go to the end of what is possible?

A discovery made in any creative action will transfer spontaneously to another part of your life. If you are a writer or a dancer, you can deepen your process through painting. What is discovered there will infiltrate every aspect of your work. You do not even need to translate what you have learned; it will happen automatically, because you have found a freer and more joyful way to create. The freedom that you reclaim as an adult will stay with you for your lifetime. It will survive even if you stop using it for years, because it melts in your blood, mixes with the air you breathe. It is like a recovered instinct, it becomes part of your natural behavior. It will manifest not only in your approach to art but in your response to life itself in all its expressions.

Your creative power, once revived, is not likely to stay silent in your daily existence. It will bring the desire to take risks, to reach for what you really want in your heart. You will remember that there is room to express what is uniquely yours and that there are options for a more harmonious way of living. Your creative power is custom-made for that purpose. It will deliver what you need, whether by color, music, words, or other forms of expression.

The tool of creation is given to you to undo the web of knowing that is woven around your brain, mind, and heart; a web that pressures you to yield to the expected result, to adhere to the blueprint of your projected life. The urge to free yourself from this web manifests as the longing to create. The web unravels when you are mature enough to jump

into yourself without knowing where you will land and without the illusion of a safety net.

You do not use art as a means to an end but as a way to inhabit and explore the present. Right and wrong fade away; you recover your sense of what is authentic in you. The next expanse of nothingness, with its latent possibilities, awaits you, draws you close. Your art is part of the big painting of your life. You are on your own, standing by yourself in the middle of creation. In the beauty of that aloneness, and in how you respond to it, you will find your passion.

For information on the programs offered by THE PAINTING EXPERIENCE STUDIO, or to receive a list of available audio- and videotapes, please contact:

The Painting Experience
P.O. Box 6067
San Rafael, CA 94903
(415) 927-5267

Participation in classes or workshops does not equip nor authorize those attending to teach this work or to use the name The Painting Experiencesm. For a list of certified teachers, please contact the above address.

appendix:
brushes,
paints,
and paper

D on't let art supplies intimidate you! Brushes, paints, and paper are the easiest materials to use—they do not require sophisticated techniques or special knowledge. Your desire to paint is what is important, and brushes, paints, and paper are a means to fulfill that desire, not an obstacle.

Find a Space

Arrange a simple and practical painting space. Keep the setup to a minimum. Don't think that you have to remodel your house or build a new studio before you can paint!

Find a private wall space where you can pin up a piece of paper. A wall works as well as an easel—you can cover it with soft fiberboard for gripping tacks, or a piece of cardboard to which you can tape your paper. Even the back of a door can be enough to get started. Get a clip-on lamp to light the paper, and a small table or shelf to hold your paints and brushes. Protect the floor with a carpet remnant or a piece of plastic. Most painting settings can be arranged with just the resources you have around the house. The point is, if you make it simple, you will be more likely to do it. Painting on an easel or wall has the advantage of keeping you standing while you work. Energy flow and aliveness tend to be greater when you're on your feet.

Make the Time

You can paint anytime—painting does not require a dedicated period. Sometimes just having fifteen minutes will begin the process, and you will then want to continue. Or try it when you first get up in the morning, before your day has begun.

It is important to remember that there is no special state that you have to be in. You could paint just as you are feeling right now, without preparing yourself in any special way. The important thing is to get started; the rest will take care of itself.

MATERIALS

The painting process is not tied to certain materials. Any materials will work when used in the right spirit. Some materials require more care and maintenance and will take more time to prepare and apply. The materials listed below are found in art-supply stores and lend themselves very well to painting for process. The essential thing is for the materials to adapt easily to your inner process, rather than your adapting to the demands of the materials. More detailed information on brand names can be found at the end of this appendix.

PAINTS

Good-quality liquid tempera paints are recommended. They are water based, non-toxic, very easy to use, and found in most art stores. They make an opaque, bright color, dry quickly, and are relatively inexpensive. Acrylics, oil paints, and watercolors are more difficult to use and may require greater attention. Gouache is a high-quality paint similar to

and more costly than liquid tempera, and an excellent medium for this process.

Do not paint directly out of the original tempera paint containers. The water from your brush will eventually cause the paints to mildew. A good trick is to transfer some colors from their jars to a plastic ice cube tray, muffin tin, or other container that can be covered with plastic wrap and stored in the refrigerator. When you have the urge to paint, pull out your containers, uncover them, and you're ready to go. Moisten the colors with a few drops of water before storing them. You will need a couple of jars of water to rinse your brushes between colors as you paint. Have some facial tissues or rags nearby to catch drips and dry brushes.

BRUSHES

A good brush will respond as if it were an extension of your hand. Investing in a few high-quality brushes will reward you many times over in the kind of painting experience you have. The best brushes for this type of work are made in France and can be found in many art stores across the United States. The teardrop-shaped brush is very practical because it holds a lot of paint and water, and can make fine or broad strokes. Excellent brushes for tempera or gouache are made of squirrel hair. Two or three brushes of various sizes are all you need.

It is also good to have a few inexpensive flat, hard brushes for those times when you need to use more pressure and do not want to be careful with soft brushes.

PAPER

Vellum bristol paper is usually sold in art stores as well as by printing-supply distributors. It is often found in pad form in smaller sizes. It is used as a book printing paper and can also be bought in bulk at paper-supply companies. It is absorbent enough for liquid tempera, yet distorts very little with the application of water. The $26'' \times 20''$ size is a good one for the creative void. Other types of watercolor paper will work with tempera paint as well.

Inexpensive paper allows you to focus on the act of creating and not worry about wasting materials. Painting on canvas can make the outcome more precious, limiting your ability to experiment freely.

ALTERNATIVES

Colored pencils, crayons, and felt-tipped or ballpoint writing pens will work quite well in more limited circumstances, such as when you are traveling. With a few pens and a sketch pad, you can create anywhere.

BRAND NAMES

PAINTS

Use high-quality liquid tempera paints.
Common brand names are Prang and Liquitex.

PRANG: Dixon Ticonderoga Company
 2600 Maitland Center, Suite 200
 Maitland, FL 32751
 (800) 824-9430

LIQUITEX: Binney & Smith Inc.
 1100 Church Lane
 P.O. Box 431
 Easton, PA 18044-0431
 (800) 272-9652

PAPER

Vellum bristol 80 lb. text
Original size 26″ × 40″, cut to 26″ × 20″
Brand name: Springhill Vellum Bristol
Manufactured by: International Paper Company
Call (800) 894-5809 or (415) 572-1373 for local distributor.

BRUSHES

Traditional French watercolor brush, KAZAN BLUE SQUIRREL, holds plenty of water and comes to an excellent point. Found in many art stores.

Manufactured by: Isabey, Smith
Sizes: #000, #1, #2, #3

MICHELE CASSOU was born and raised in southern France. As a young adult, she moved to Paris, where she studied law, literature, and art. Inspired by watching children paint, she discovered a way to express herself spontaneously and without need for conventional training. By her early twenties, painting had become her full-time passion. A unique approach to creativity grew out of her many years of "just painting for herself," and her intense desire to share her discoveries led her to work with other people and to lead groups in the creative process. In 1976, she founded The Painting Experience Studio in San Francisco, where she has touched many people's lives through ongoing classes and workshops, as well as in centers throughout the United States. She continues to paint and teach in the San Francisco Bay Area.

STEWART CUBLEY was originally trained as a scientist and engineer. After meeting Michele in 1976, he painted for the first time, and soon thereafter began a second career as a painter and then a teacher of creative painting. Together with Michele, he founded The Painting Experience Studio in San Francisco. Their unique approach to the creative process has proved to be of interest to a wide variety of disciplines, including art, psychology, education, therapy, and meditative practices. Stewart currently lives in the San Francisco Bay Area and leads workshops and classes throughout the country in creative painting.